RAYMOND CHANDLER'S

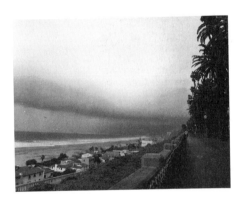

LOS ANGELES

ELIZABETH WARD AND ALAIN SILVER

THE OVERLOOK PRESS WOODSTOCK, NEW YORK

First published in 1987 by
The Overlook Press
Lewis Hollow Road
Woodstock, New York 12498

Library of Congress Cataloging-in-Publication Data

Chandler, Raymond, 1888–1959.
 Raymond Chandler's L.A.
 Excerpts from the works of Raymond Chandler,
juxtaposed to photographs of Los Angeles.
 1. Chandler, Raymond, 1888–1959—Quotations.
2. Chandler, Raymond, 1888–1959—Homes and haunts—
California—Los Angeles—Pictorial works. 3. Los
Angeles (Calif.)—Description—Views. 4. Literary
landmarks—California—Los Angeles—Pictorial works.
I. Silver, Alain, 1947– . II. Ward, Elizabeth,
1952– . III. Title. IV. Title: L.A.
PS3505.H3224A6 1987 813'.52 86–18007

Book and Jacket Design by Linda Kosarin

ISBN: 0-87951-351-9
Third Printing

Manufactured in the United States of America

DEDICATION

In memory of our Parents,
Roberta Ward
and
Elmer Silver

CONTENTS

INTRODUCTION .. 1

LIST OF EXCERPTS ... 4

SELECTED BIBLIOGRAPHY 221

FILMOGRAPHY ... 229

NOTES .. 233

REGARDING THE PHOTOGRAPHS 237

ACKNOWLEDGMENTS 239

INTRODUCTION

*B*ut down these mean streets a man must go who is not himself mean, who is neither tarnished nor afraid The detective in this kind of story must be such a man. He is the hero; he is everything The story is this man's adventure in search of a hidden truth.

—— **Raymond Chandler,**
"The Simple Art of Murder"

It is still possible to walk the "mean streets" of Los Angeles in the tracks of Detective Philip Marlowe and to bask in that "special brand of sunshine" that Marlowe imagined falling there.

Few if any cities as young as Los Angeles share its breadth of associations. The desert presses the city from one side, and the ocean curls lazily against it on the other. There are bright, sunlit vistas and dark, windswept canyons; Spanish homes and Streamline Moderne overlooking the surf or clinging to the side of the Hollywood Hills; ranch-style suburban tracts that stretch for miles and grimy, downtown congestion. There are cities within it. Some are enclaves for the very rich; others, refurbished ghettos. Thanks to the film industry, the idiosyncrasies both of the Los Angeles landscape and of its inhabitants are known to millions around the world who go to movies and watch television. Many of these people are also familiar with a writer who described L.A. like no one else ever had.

Raymond Chandler portrayed Los Angeles and its environs with a style that was at once realistic, cynical, and romantic. With murderous wit and uncanny detail, Chandler expressed his admiration or disdain for the eclectic architecture, the ethnic uncertainty, and even the monotonous climate. Chandler's imagination roamed freely over the urban sprawl of Los Angeles and described the city's most evocative aspects, good and bad: "A city no worse than others, a city rich and vigorous and full of pride, a city lost and beaten and full of emptiness." (*The Long Goodbye*). Whether in the back alleys of Chinatown or the baronial manors of Pasadena, whether probing the open discord of Hollywood or the repressed fears of "Bay City," Chandler's characters are at home in their surroundings.

Chandler, it seems, never was. He moved constantly, sometimes barely settling in at one address before packing up and relocating to another. Just as much of the real Los Angeles in which Chandler lived became the background for his fiction, much of Chandler's restlessness is infused into Marlowe and his other creations. When Marlowe has a problem, he takes a drive around town. He uses the passage through narrow streets, along broad boulevards, or over early freeways to look at the view and to look for answers.

Like all artistic transmutations, the differences between what Chandler wrote about the city and what it looked like at the time are sometimes subtle, sometimes broad, and always peculiar to Chandler. Unlike Agatha Christie, Arthur Conan Doyle, or even Dashiell Hammett, Chandler's descriptions are never pure "objectivism." Chandler is usually more interested in conveying the feel of a place to his reader than in merely relating its physical appearance. "The memories of old cigars clung to its lobby like the dirty gilt on its ceiling and the sagging springs of its leather lounging chairs." Or "The Dancers was a blaze of light. The terrace was packed. The parking lot was like ants on a piece of overripe fruit." (*The Little Sister*). His use of unusual similies has been copied by many and parodied by perhaps even more; but his descriptions still possess a brashness that is undeniably vivid. Because almost all of his narratives are in the first person, the landscape is always reflected in his protagonist's eyes. Marlowe's eyes seldom overlook the ironic or the absurd detail, no matter how serious the moment.

From his earliest days as a denizen of Los Angeles, Chandler must have appreciated the volatility of his surroundings. As the city expanded both outward and upward, its boundaries and skyline were in constant flux. The structures and streets that Chandler knew are mostly gone, either leveled or metamorphosed into new shapes and designs. Several of the sites photographed for this book just within the past two years are already gone. Of course, nothing is fixed immutably; but one may still take Chandler's prose, half a century out of his typewriter, and go out to discover that much of its inspiration remains.

This book is an attempt to illustrate photographically Chandler's literary odyssey through Los Angeles. The challenge to those searching for Marlowe's footprints is to distinguish what Chandler saw from what he overlooked. Many of the actual sites, as Chandler saw them, are lost in time. Even more of Chandler's locales are pastiches of the real and the imagined, of actual places embellished or diminished to fit the needs of his narrative. As a result, the challenge was sometimes not merely to photograph a place that no longer existed but to find one that never was.

In the excerpts we have chosen, our underlying concept has been to find a visual equivalent to Chandler's descriptions. Of the photographs that follow, some are of sites that were landmarks even in Chandler's time and are still accessible for inspection by the curious. Some are of structures that Chandler certainly never saw except in his mind's eye, structures that were meant to be unprepossessing or anonymous. Many, no doubt, will question some of our choices, for they are personal ones. This is particularly true of the sites we chose to represent the fictional boulevards and buildings. Even in the case of an explicit reference— to the Los Angeles City Hall, for instance—there are still choices of angle, exposure, print contrast, and so on. Someday we may find the perfect embodiments of Eddie Mars's Cypress Club or Dr. Amthor's secluded eyrie. Often, however, in seeking out the places Chandler used merely as models, we found the actual locations to be less than "authentic," lacking either the stature or pungency that Marlowe perceived in them or with which a skilled writer imbued them.

The photographs in this book are arranged to provide an armchair tour of Raymond Chandler's Los Angeles, but most of the places Chandler described can also be visited in person. It is physically possible to visit these sites in a day or two, but it is certainly not recommended. The easiest or at least most traditional way to tour Southern California is by car. Marlowe occasionally drove his Oldsmobile convertible with the top down; but, of course, any kind of vehicle will do. In fact, with careful planning, most of Chandler's L.A. can be visited by public transportation. (For more information about touring Los Angeles, refer to the Bibliography.)

Fifty years have passed since Raymond Chandler published his first story in *Black Mask*; twenty-five years since he died. Los Angeles has not stood still. Except in the strange way that a place may appear to change without really changing at all.

LIST OF EXCERPTS

		Page
1.	A BIG DRY SUNNY PLACE (*The Little Sister*)	6
2.	EMPTY STEPS (*"Trouble Is My Business"*)	16
3.	UNION STATION (*Playback*)	20
4.	NEWTON STREET (*"Spanish Blood"*)	24
5.	HOTEL METROPOLE (*"Nevada Gas"*)	26
6.	DOWNTOWN PEOPLE (*The High Window*)	28
7.	TWO LONGS AND TWO SHORTS (*The Little Sister*)	30
8.	FLORIAN'S (*Farewell, My Lovely*)	32
9.	BELFONT BUILDING (*The High Window*)	34
10.	THE CORRIDOR (*The Long Goodbye*)	38
11.	BUNKER HILL (*"The King in Yellow"*)	40
12.	SECOND STREET TUNNEL (*The Big Sleep*)	44
13.	WE'RE HEADED (*"Finger Man"*)	46
14.	TRELOAR BUILDING (*The Lady in the Lake*)	50
15.	JESSE FLORIAN'S PLACE (*Farewell, My Lovely*)	54
16.	GRAY LAKE (*"Finger Man"*)	58
17.	BRYSON TOWER APARTMENTS (*The Lady in the Lake*)	62
18.	BULLOCK'S GREEN-TINGED TOWER (*The Big Sleep*)	66
19.	THE DEPARTMENT STORE STATE (*The Little Sister*)	70
20.	WONDERFUL WHAT HOLLYWOOD WILL DO (*The Little Sister*)	72
21.	RARE BOOKS AND DELUXE EDITIONS (*The Big Sleep*)	78
22.	MY DOG HOUSE (*The Long Goodbye*)	80
23.	COME ON IN (*The Little Sister*)	84
24.	NOT THE BRAINIEST (*The Little Sister*)	90
25.	WARM WEATHER (*The High Window*)	94
26.	A MAIL ORDER CITY (*The Little Sister*)	98
27.	THE HOBART ARMS (*"Finger Man"*)	102

28. NOT STRICTLY A BUNGALOW COURT (*"The King in Yellow"*) 106

29. WE WENT WEST (*Farewell, My Lovely*) . 110

30. WET EMPTINESS (*The Big Sleep*) . 114

31. A LITTLE TROUBLE (*Farewell, My Lovely*) . 118

32. BAY CITY IS A NICE TOWN (*Farewell, My Lovely*) . 122

33. A SPECIAL BRAND OF SUNSHINE (*Farewell, My Lovely*) 126

34. SANCTUARY (*Farewell, My Lovely*) . 128

35. IDAHO STREET (*The Little Sister*) . 132

36. OUTSIDE (*Farewell, My Lovely*) . 134

37. WHAT I NEEDED, WHAT I HAD (*Farewell, My Lovely*) 138

38. TWO HUNDRED AND EIGHTY STEPS (*Farewell, My Lovely*) 142

39. A FAMILY THINGS HAPPEN TO (*The Big Sleep*) . 148

40. IF ANYBODY EVER BOTHERS YOU (*"Red Wind"*) . 150

41. SOME REALTOR'S DREAM (*Farewell, My Lovely*) . 154

42. FOUR SQUARE MILES (*Farewell, My Lovely*) . 158

43. MEETING AT THE RITZ-BEVERLY (*The Long Goodbye*) 160

44. CALLING ON FOUR MILLION DOLLARS (*The Big Sleep*) 164

45. DO YOU LIKE ORCHIDS? (*The Big Sleep*) . 168

46. TEACH ME? (*The Big Sleep*) . 170

47. LAVERNE TERRACE (*The Big Sleep*) . 174

48. RED WIND (*"Red Wind"*) . 176

49. DRY LIKE THE ASHES OF LOVE (*"Red Wind"*) . 180

50. EMPTY POOL (*The Long Goodbye*) . 182

51. CRAWLING LAVA (*The High Window*) . 184

52. I BELONGED IN IDLE VALLEY (*The Long Goodbye*) . 186

53. BREATHLESS AIR (*The High Window*) . 188

54. LA CRESCENTA FLOOD AREA (*"Nevada Gas"*) . 192

55. THE SPOKES OF A WHEEL (*The Lady in the Lake*) . 194

56. CAMP KILKARE (*The Lady in the Lake*) . 198

57. PUMA LAKE DAM (*The Lady in the Lake*) . 202

58. LIKE A FLY IN AMBER (*The Lady in the Lake*) . 204

59. CARCASSES (*Playback*) . 208

60. VALLEY MOONLIGHT (*The High Window*) . 212

61. YOU'RE NOT HUMAN TONIGHT, MARLOWE (*The Little Sister*) 216

1 / A BIG DRY SUNNY PLACE

"*I used to like this town,*" *I said, just to be saying something and not to be thinking too hard. "A long time ago. There were trees along Wilshire Boulevard. Beverly Hills was a country town. Westwood was bare hills and lots offering at eleven hundred dollars and no takers. Hollywood was a bunch of frame houses on the inter-urban line. Los Angeles was just a big dry sunny place with ugly homes and no style, but good hearted and peaceful. It had the climate they just yap about now. People used to sleep out on porches. Little groups who thought they were intellectual used to call it the Athens of America. It wasn't that, but it wasn't a neon-lighted slum either.*"

The Little Sister

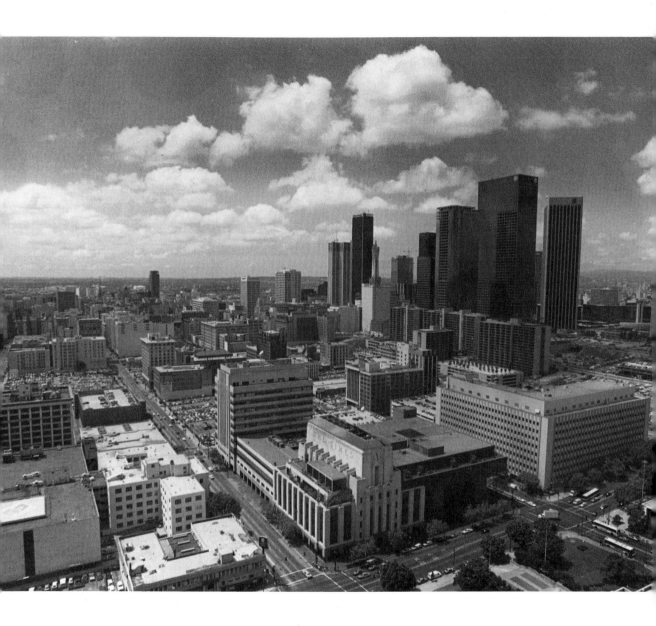

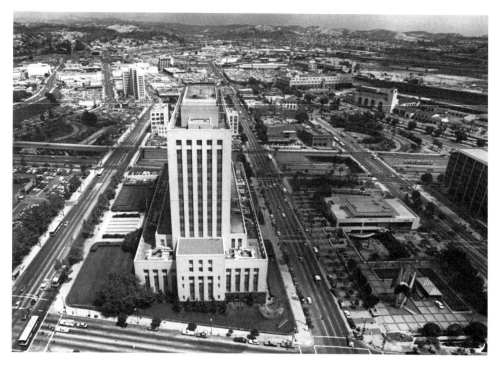

Looking north from the City Hall observation deck.

Los Angeles considers itself among the foremost cities in the world. On a clear day, like the one pictured here, it doesn't need statistics to prove it. From the 27th floor of the City Hall, you can see south all the way to the San Pedro wharves and even glimpse a sliver of blue ocean. With a little squinting the hills of Catalina Island may be visible beyond a thin band of yellow smog that has been pushed out to sea. Just a few blocks southwest of City Hall are the chrome and tinted-glass high rises of the "new downtown" erected since the urban renewal of the 1960s. More clusters of high rises in Century City and Westwood spike the western view along Wilshire Boulevard toward Santa Monica Bay. To the northwest, Hollywood nestles against the foothills of Cahuenga Pass. Directly north, L.A.'s earliest freeway cuts through Elysian Park as it carries commuters to the city's first suburbs of Pasadena and Glendale. Northeast, warehouses and rail spurs line the Los Angeles River and separate the industrial backside of downtown from the working class neighborhoods of Boyle Heights and East L.A. Interstate 5, formerly U.S. 101, veers off diagonally to the southeast. It is only three hours driving to the Mexican border, where Marlowe drove his friend Terry Lennox in *The Long Goodbye*.

When Chandler first arrived in Los Angeles, the downtown streets were only partially paved. Horses and buggies were still common sights, but an excellent electric rail system connected downtown with many of the outlying areas. These routes were later torn up as the freeways

engulfed their right-of-way. Chandler arrived in the same year that William Mulholland completed the Owens River Aqueduct, a still controversial water project that increased the city's water supply by fivefold. Control of this water turned Los Angeles into a metropolis as it annexed most of the adjacent communities, which lacked their own supply.

<p style="text-align:center">*　　　*　　　*</p>

Although born in Chicago in 1888, Raymond Chandler arrived in L.A. in 1913 looking and sounding like an Englishman. Chandler's Protestant-Irish mother, Florence, met and married Maurice Chandler, a Quaker railroadman, while visiting her sister in Omaha. The newlyweds moved to Chicago, where Raymond was born. Seven years later, Florence filed for divorce and took her son to London, where they lived with her mother and unmarried sister, who had moved from family holdings in Ireland.

Chandler lived with his mother, grandmother, and aunt until he finished his English education. The family had long since lost their inherited wealth; but they had enough money and status left to enroll Chandler as a "day boy" at Dulwich College, an upper middle class school. His uncle, a solicitor and head of the family firm in Ireland, wanted Chandler to qualify for a civil service post with the British Admiralty. The young Chandler became a naturalized British citizen and after finishing school spent a year in France and Germany studying international law and continental life. He returned to London and placed third among the six hundred applicants in the Admiralty examinations and was assigned as "Assistant Stores Officer" in the Naval Supplies Branch.

Chandler's hope was that this mundane job would allow him the spare time to pursue a writing career, but he became too depressed to accomplish anything. After six months, much to his family's dismay, Chandler quit the Admiralty and found a job as a reporter. Chandler would later recount that he was fired from that job because he could never find the addresses for the assignments his editor gave him. He was more successful at writing poetry, commentary, and criticism for the *Westminster Gazette* and the *Academy Bloomsbury*. To supplement his meager writing income, Chandler worked as a substitute teacher back at Dulwich College. After five years of being what he called "holed up in Bloomsbury,"[1] Chandler felt he was getting nowhere. Barely subsisting and unwilling to try his hand at commercial writing, such as serial fiction for the tabloid newspapers, Chandler decided that success in London was beyond his reach. At the age of twenty-three, he returned for a fresh start to an America he barely remembered.

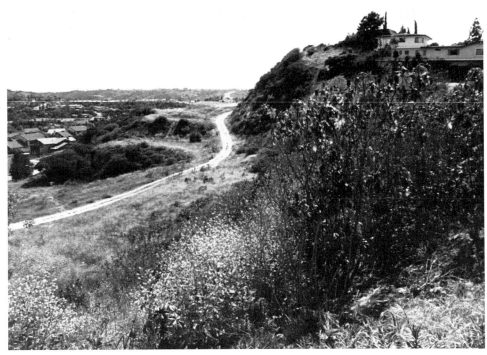

Beverly Hills was a country town.
Cul-de-sac, just east of Beverly Glen Boulevard and Mulholland Drive.

It was once possible to ride on horseback through the bean fields from the Biltmore Hotel downtown all the way to the Beverly Hills Hotel. The fields and hills of dry, golden grasses and scattered live oaks have given way to black glass monoliths and expensive estates; but north of Sunset Boulevard a few vestiges of a country town remain.

The iron-gated residential park called Chester Place is now the downtown campus of Mount St. Mary's College. It was developed in 1895 as a planned community for thirteen mansions, seven of which remain in sedate glory. The Doheny Mansion was built in 1900 for the Posey family but was purchased in 1901 for $120,000 in gold coins by E. L. Doheny. In 1892 Doheny had become the first man to strike oil in L.A. (He later built Greystone Mansion in Beverly Hills for his son. See Excerpt 44.) Over the years, the Dohenys acquired the entire park. Mrs. Doheny, known as "Countess Estelle," was a devout Roman Catholic, and upon her death in 1958 willed Chester Place to the Los Angeles Archdiocese to establish the college campus. Chandler was certainly familiar with the notable Doheny family and while he was vice-president of a rival oil syndicate from 1922 to 1932, may even have met E. L. Doheny in the course of business.

Mount St. Mary's allows visitors to its Chester Place campus but restricts them to the curbside walkways and does not allow photographs. The college sometimes conducts tours,

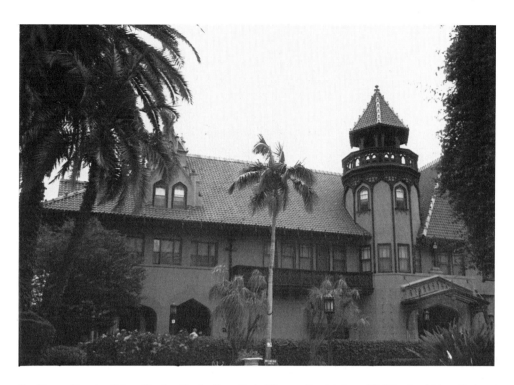

The Athens of America. Doheny Mansion, Chester Place. West of Figueroa Street, between 23rd Street and Adams Boulevard.

often in association with the city's preservation group, the Los Angeles Conservancy.

This residential development was advertised by its owner, Pomeroy Powers, who at the time was also chairman of the City Council, as a "second Chester Place." Although less grandiose, these houses originally faced the site of the Los Angeles Country Club, but now only a small park remains. The Powers House was the last house on the block to be completed in 1905. His family occupied each house as it was finished; and he sold each before beginning the next. According to legend, after completion of the final home, the developer wanted to move on, but his wife refused to pack.

* * *

Chandler knew this neighborhood from the days before World War I. His good friends, Warren and Alma Lloyd, lived near here at 713 South Bonnie Brae Street. Chandler had met the couple during his 1912 voyage from England to New York. They were the only people he knew in Los Angeles and may have been a significant factor in his ultimate decision in 1913 to come all the way west.

Good hearted and peaceful.
The Powers House, 1345 Alvarado Terrace, west of Figueroa Street, south of Pico Boulevard, east of Alvarado Boulevard and Hoover Streets.

When Chandler arrived in America, he left New York City almost immediately for St. Louis, where he stayed and worked for a brief time before continuing on to his relatives in Omaha. Chandler soon moved on to California "with a beautiful wardrobe, a public school accent, no practical gifts for earning a living, and a contempt for the natives which, I am sorry to say, has in some measure persisted to this day."[2]

During his first months in L.A., Chandler found only odd jobs. He picked apricots for twenty cents an hour and strung tennis rackets for $12.50 a week. Finally, he completed a correspondence business course and, using Warren Lloyd's influence, became bookkeeper for a dairy. Accounting for milk deliveries was not much different from his old job at the Admiralty; but life after work was much more entertaining. Warren Lloyd, who had a doctorate in philosophy from Yale, was legal counsel for several oil companies and had also cowritten a book on abnormal psychology. His wife Alma was a sculptor and singer. They regularly hosted parties featuring the musical talents of Alma and their other friends or devoted to discussions that in their eclectic group ranged from politics and science to the occult. They also liked to tour around the city on warm afternoons in the Lloyds' convertible. On these excursions, Chandler might recline in the back seat next to a well-stocked picnic basket.

When the United States entered World War I in 1917, Chandler, as a British national,

chose to join the Canadian army. He arrived in France in spring of 1918, soon became a platoon commander, and saw heavy action. He later wrote that "once you have had to lead a platoon into direct machine-gun fire, nothing is ever the same again."[3] In June, he was the sole survivor of an artillery barrage that wiped out his unit. Following hospitalization with a concussion, he transferred to the Royal Air Force; but the Armistice was signed before his flight training was completed.

After being mustered out of the service in Victoria, British Columbia, Chandler spent some months visiting army comrades who lived along Puget Sound. "Goldfish," a short story published in 1936, is set in this area and demonstrates that Chandler's literary imagination could discover menace beyond the city streets and urban congestion of Southern California.

Chandler then spent some time living in San Francisco working for an English bank. This didn't seem to satisfy him, and he finally returned to Los Angeles in late 1919. He took a job with a newspaper, the *Daily Express*, but resigned after only a month and a half. Warren Lloyd's brother offered Chandler an accounting position at his Dabney-Johnson Oil Corporation, which controlled burgeoning oil interests in the city. Chandler ultimately rose to office manager and vice-president. He took a good deal of pride in being an excellent manager and believed he really knew how to bring out the best qualities in the personnel. His interest in management made the routine less boring, and he settled into the life of a promising executive. He also realized that he was in love.

The Lloyds remained loyal to Chandler even after his confession of love for Cissy Pascal, the wife of another of their friends. Cissy divorced her husband in 1920 but did not marry Chandler until four years later, after the death of his mother, who was opposed to the union.

Next Page:
Neon-lighted slum.
View of First Street as it bridges Glendale Boulevard, looking north.

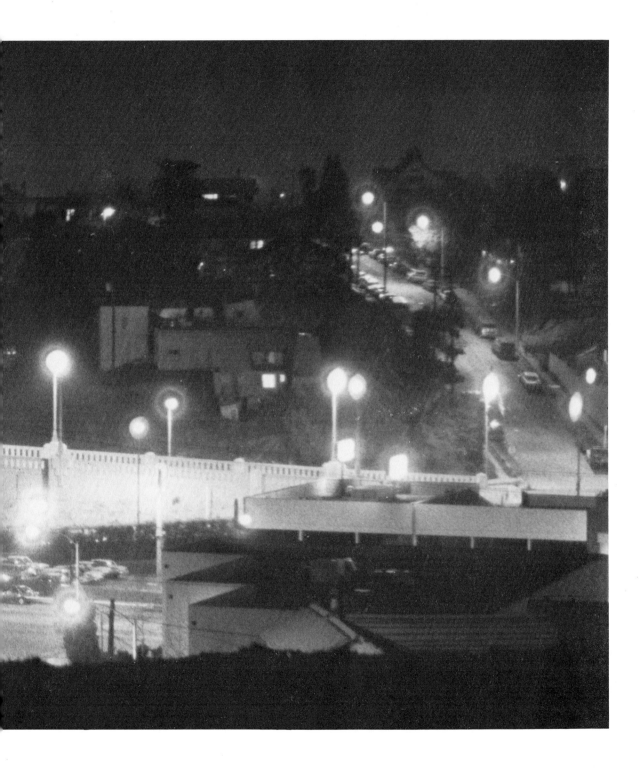

2 / EMPTY STEPS

"*W*ell, good night, boys."

Neither of them spoke to me.

I went out, along the corridor and down in the night elevator to the City Hall lobby. I went out the Spring Street side and down the long flight of empty steps and the wind blew cold. I lit a cigarette at the bottom. My car was still out at the Jeeter place. I lifted a foot to start walking to a taxi half a block down across the street. A voice spoke sharply from a parked car.

"Come here a minute."

It was a man's voice, tight, hard. It was Marty Estel's voice. It came from a big sedan with two men in the front seat. I went over there. The rear window was down and Marty Estel leaned a gloved hand on it.

"Get in." He pushed the door open. I got in. I was too tired to argue. "Take it away, Skin."

The car drove west through dark, almost quiet streets, almost clean streets. The night air was not pure but it was cool. We went up over a hill and began to pick up speed.

Trouble Is My Business

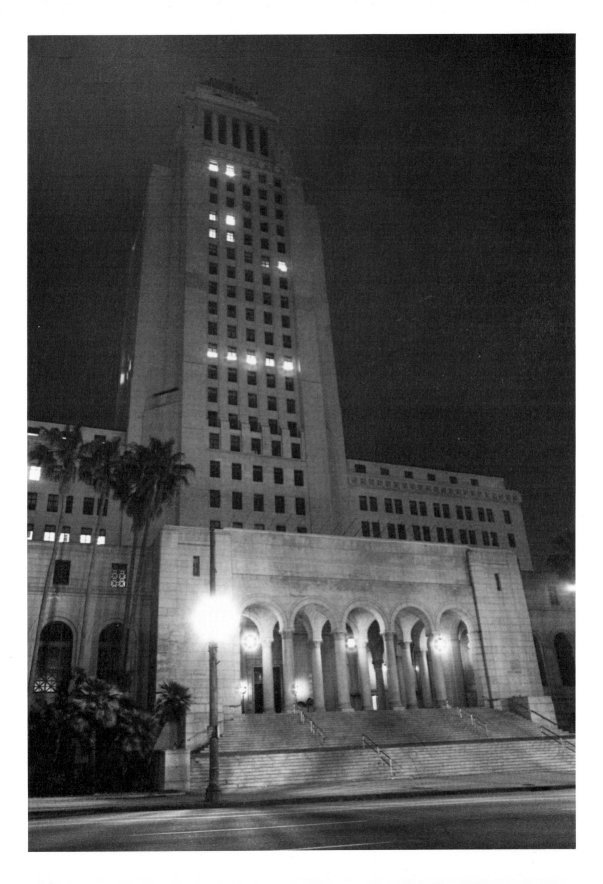

This monument of Art Deco geometry was completed in 1928, after plans by John C. Austin, Albert C. Martin, Sr., and John and Donald Parkinson. Austin Whittlesey designed the interior. The Los Angeles City Hall is a classic example of solid optimism and civic pride, which until 1957 made it the only building in the city permitted to exceed the thirteen-story height limit imposed in deference to the region's history of seismic instability. Most Southern Californians have a fatalistic disregard of earthquakes and view preparation for them as only slightly more necessary than a pair of snow shoes.

Great care was taken to see that the City Hall was constructed of native materials. California granite faces the exterior up to the fourth floor. A melange of local ores formed the bronze for the ceremonial doors of the forecourt. The building's mortar was mixed with sand from each county, cement from each mill in the state, and water from each of the twenty-one missions. Inside, the building features a four-story Spanish-Gothic rotunda and, in a heavily romantic style, several marble mosaics depicting local history. The building has an observation deck on the 27th floor.

This may be the world's most filmed city hall. It has often been featured in locations for movies and television productions. In the 1950s, the series "Dragnet" and "Superman" both incorporated views of the building into their title sequences. The City Hall design was influenced by that of the Public Library on 630 West Fifth Street, between Flower and Grand streets. The library was completed three years earlier by different architects, but it was so popular in style that it influenced many later buildings.

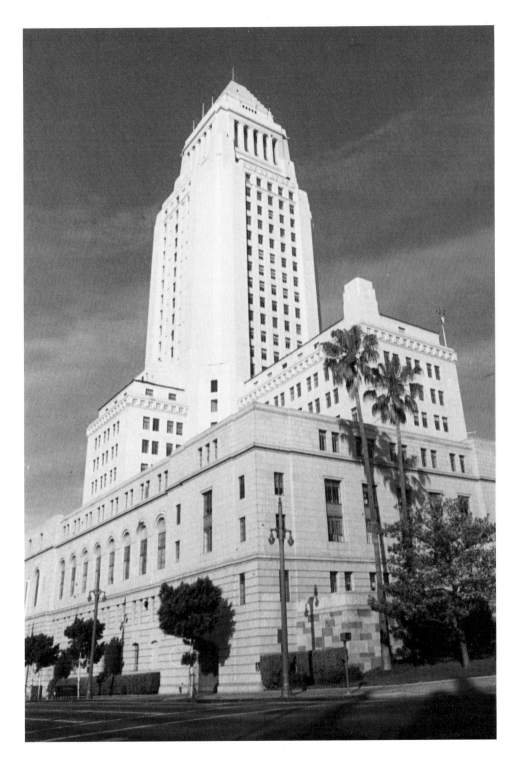

Los Angeles City Hall viewed from its northwest corner, Temple and Main streets.

3/ UNION STATION

There was nothing to it. The Super Chief was on time, as it almost always is, and the subject was as easy to spot as a kangaroo in a dinner jacket She sat down and looked at the floor. An unhappy girl, if ever I saw one . . .

After a while she moved across the arches outside of which the taxis wait. She looked left at the coffee shop, turned and went into the main waiting room, glanced at the drugstore and the newsstand, the information booth, and the people sitting on the clean wooden benches. Some of the ticket windows were open, some not. She wasn't interested in them. She sat down again and looked up at the big clock.

Playback

Union Station waiting area.

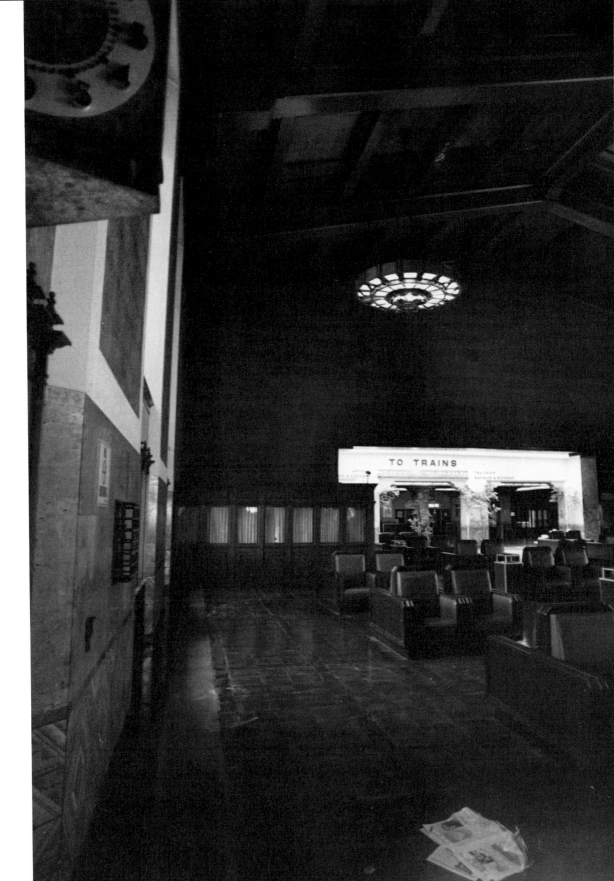

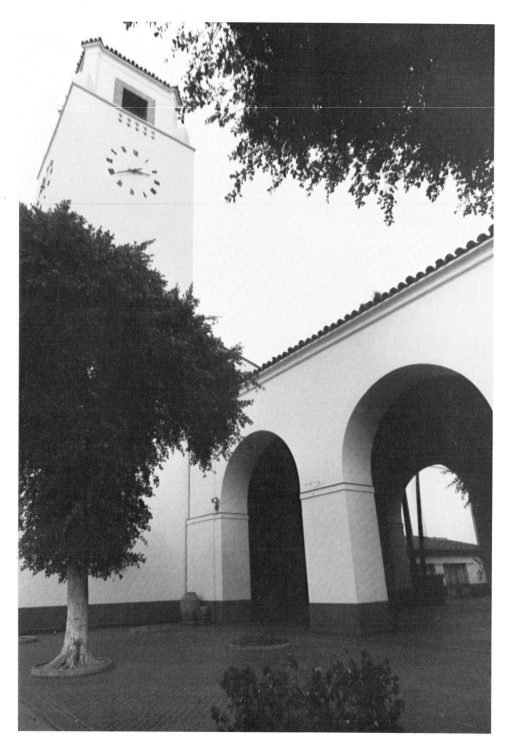

Union Station, 800 North Alameda Street, just behind Olvera Street.

Rail lines under Macy Street heading south behind Union Station.

This Spanish-style railroad depot was completed in 1939 after the design of John and Donald Parkinson. Los Angeles waited until aviation was already threatening the passenger train system before building this comfortable rail terminus. In earlier years, anybody who was somebody got off the Los Angeles-bound train in Pasadena.

The interior of the building has the vast hollowness of an ancient and empty museum. Nobody seems to be going anywhere, but a few ticket agents and porters stand ready just in case. Occasionally, the announcement of an arriving train is whispered through the public address system. A handful of passengers shuffle through the lobby and quickly disappear through the glass doors to the parking lot.

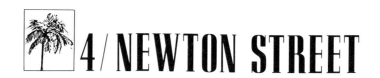

4/ NEWTON STREET

*N*ewton Street, between Third and Fourth, was a block of cheap clothing stores, pawnshops, arcades of slot machines, mean hotels in front of which furtive-eyed men slid words delicately along their cigarettes, without moving their lips.

Spanish Blood

Downtown hotel along Main Street.

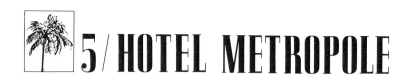

5/ HOTEL METROPOLE

*I*t was twenty-five minutes past nine when he got to the corner of Seventh and Spring, where the Metropole was.

It was an old hotel that had once been exclusive and was now steering a shaky course between a receivership and a bad name at Headquarters. It had too much oily dark wood paneling, too many chipped gilt mirrors. Too much smoke hung below its low beamed lobby ceiling and too many grifters bummed around in its worn leather rockers.

Nevada Gas

Hotel Cecil, Main Street.

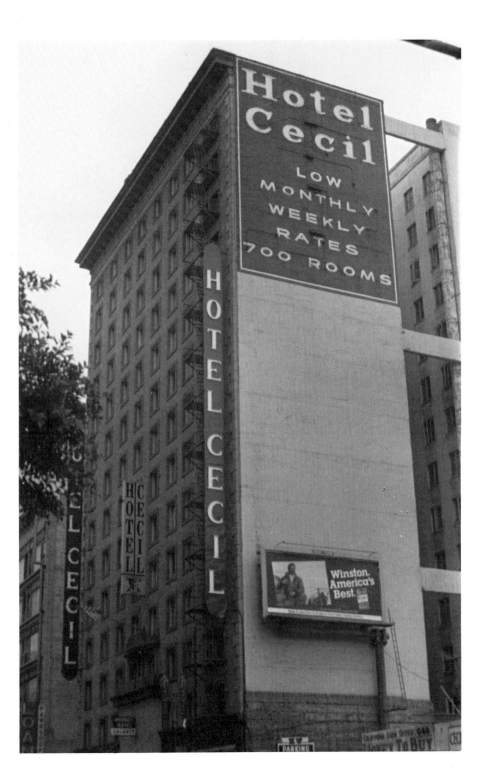

6 / DOWNTOWN PEOPLE

*I*n and around the old houses there are flyblown restaurants and Italian fruitstands and cheap apartment houses and little candy stores where you can buy even nastier things than their candy. And there are ratty hotels where nobody except people named Smith and Jones sign the register and where the night clerk is half watchdog and half pander.

Out of the apartment houses come women who should be young but have faces like stale beer; men with pulled-down hats and quick eyes that look the street over behind the cupped hand that shields the match flame; worn intellectuals with cigarette coughs and no money in the bank; fly cops with granite faces and unwavering eyes; cokies and coke peddlers; people who look like nothing in particular and know it, and once in a while even men that actually go to work. But they come out early, when the wide cracked sidewalks are empty and still have dew on them.

The High Window

Shop along Colorado Boulevard, Sunland.

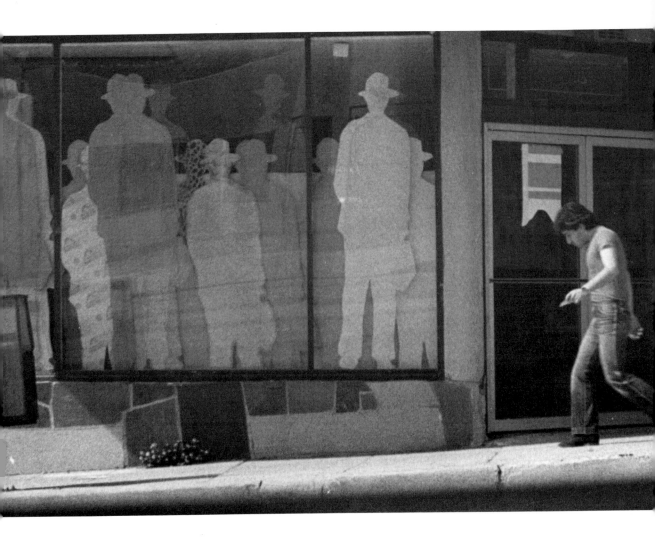

7/ TWO LONGS AND TWO SHORTS

Room 332 was at the back of the building near the door to the fire escape. The corridor which led to it had a smell of old carpet and furniture oil and the drab anonymity of a thousand shabby lives. The sand bucket under the racked fire hose was full of cigarette and cigar stubs, an accumulation of several days. A radio pounded brassy music through an open transom. Through another transom people were laughing fit to kill themselves. Down at the end by Room 332 it was quieter.

I knocked the two longs and the two shorts as instructed. Nothing happened. I felt jaded and old. I felt as if I had spent my life knocking at doors in cheap hotels that nobody bothered to open. I tried again. Then turned the knob and walked in. A key with a red fiber tab hung in the inside keyhole.

The Little Sister

Hotel Chandler, Main Street.

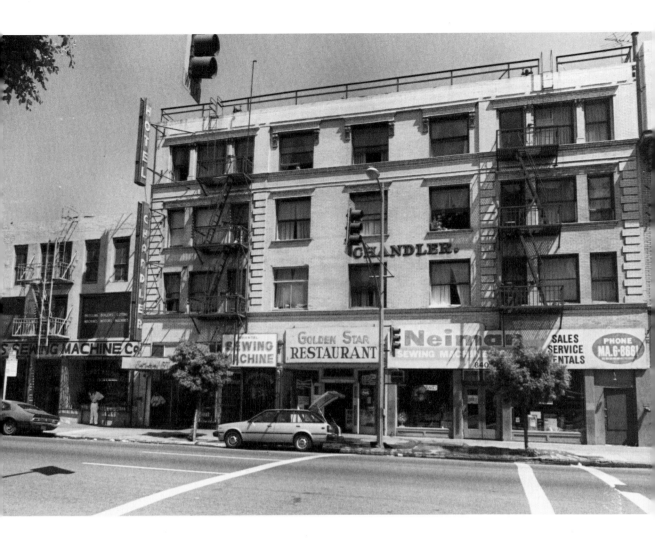

8 / FLORIAN'S

*I*t was one of the mixed blocks over on Central Avenue, the blocks that are not yet all Negro.

It was a warm day, almost the end of March, and I stood outside the barber shop looking up at a jutting neon sign of a second floor dine and dice emporium called Florian's. A man was looking up at the sign too. He was looking up at the dusty windows with a sort of ecstatic fixity of expression, like a hunky immigrant catching his first sight of the Statue of Liberty. He was a big man but not more than six feet five inches tall and not wider than a beer truck. . . He was about ten feet away from me.

Even on Central Avenue, not the quietest dressed street in the world, he looked about as inconspicuous as a tarantula on a slice of angel food. . . .

Farewell, My Lovely

Buildings along Central Avenue, about two miles due south of downtown.

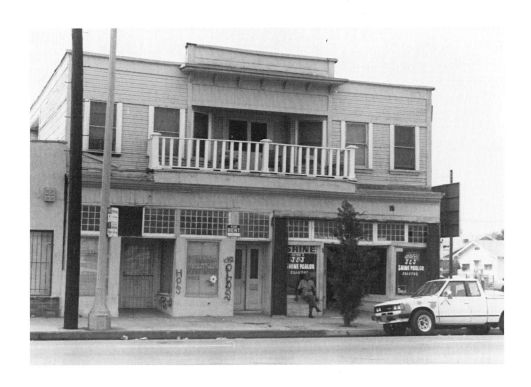

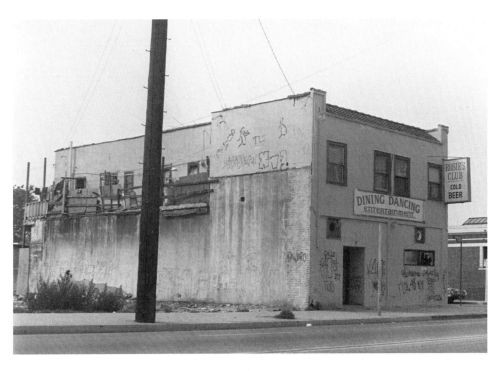

9 / BELFONT BUILDING

*T*he Belfont Building was eight stories of nothing in particular that had got itself pinched off between a large green and chromium cut rate suit emporium and a three-story and basement garage that made a noise like lion cages at feeding time. The small dark narrow lobby was as dirty as a chicken yard. The building directory had a lot of vacant space on it. Only one of the names meant anything to me and I knew that one already. Opposite the directory a large sign tilted against the fake marble wall said: Space for Renting Suitable for Cigar Stand. Apply Room 316.

There were two open-grill elevators but only one seemed to be running and that not very busy. An old man sat inside it slack-jawed and watery-eyed on a piece of folded burlap on top of a wooden stool. He looked as if he had been sitting there since the Civil War and had come out of that badly.

I got in with him and said eight, and he wrestled the doors shut and cranked his buggy and we dragged upwards lurching. The old man breathed hard, as if he was carrying the elevator on his back.

The High Window

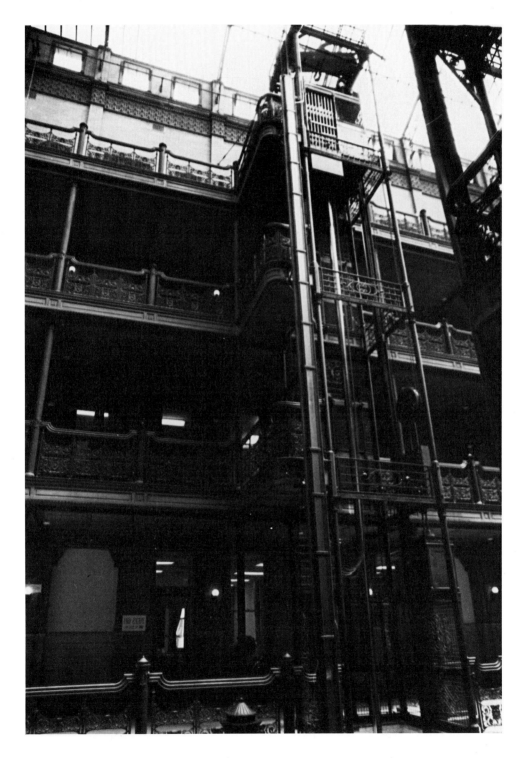

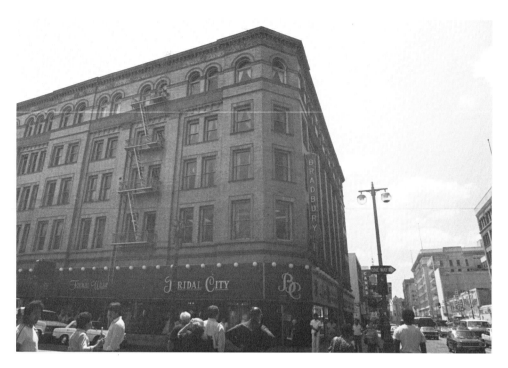

Bradbury Building, 304 South Broadway, the southwest corner of Third Street and Broadway.

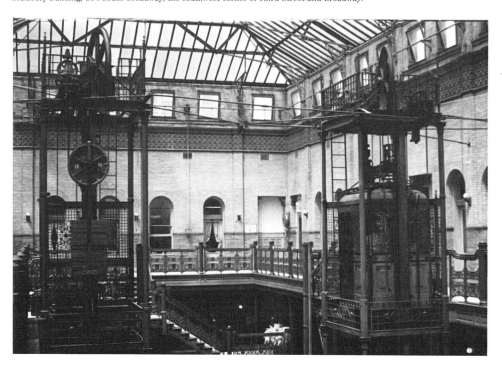

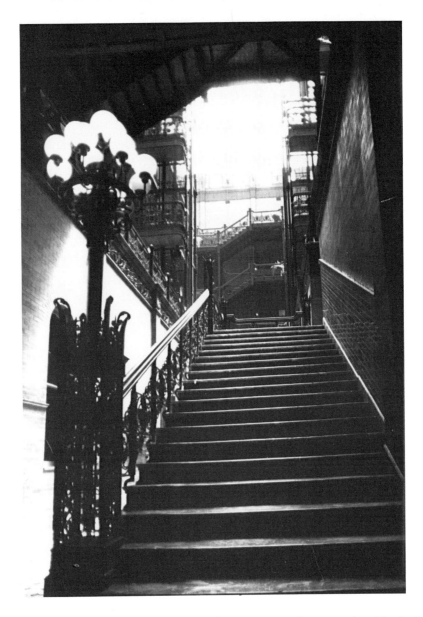

From the outside, the Bradbury Building is nondescript, an effect exacerbated by the Baroque-pastiche facade of the Million Dollar Theater across the street. Inside is a marvel of Gay Nineties style and engineering. While Chandler only mentions the twin open-grille elevators, there is also an impressive vaulted roof with a central skylight. The building's design was a first effort of draftsman George Wyman for mining millionaire Lewis Bradbury and was completed in 1893. The building has been recently restored and encourages visitors. A peek inside and a ride in the vintage elevators costs two dollars. In MARLOWE, the 1969 film adaptation of *The Little Sister*, Marlowe's "Hollywood" office is located in the Bradbury Building, and several scenes take place in its stairways and corridors.

10 / THE CORRIDOR

*T*he corridor of the sixth floor was narrow and doors had frosted glass panels. It was older and much dirtier than my own building. It was loaded with doctors, dentists, Christian Science practitioners not doing too good, the kind of lawyers you hope the other fellow has, the kind of doctors and dentists who just scrape along. Not too skillful, not too clean, not too much on the ball, three dollars and please pay the nurse; tired, discouraged men who know just exactly where they stand, what kind of patients they can get and how much money they can be squeezed into paying. Please Do Not Ask For Credit. Doctor is In, Doctor is Out. That will be Three Dollars. Please Pay the Nurse.

The Long Goodbye

Office corridor of a building on Vermont Avenue.

11 / BUNKER HILL

*C*ourt Street was old town, wop town, crook town, arty town. It lay across the top of Bunker Hill and you could find anything from down-at-heels ex-Greenwich-villagers to crooks on the lam, from ladies of anybody's evening to County Relief clients brawling with haggard landladies in grand old houses with scrolled porches, parquetry floors, and immense sweeping banisters of white oak, mahogany and Circassian walnut.

It had been a nice place once, had Bunker Hill, and from the days of its niceness there still remained the funny little funicular railway, called the Angel's Flight, which crawled up and down a yellow clay bank from Hill Street.

The King in Yellow

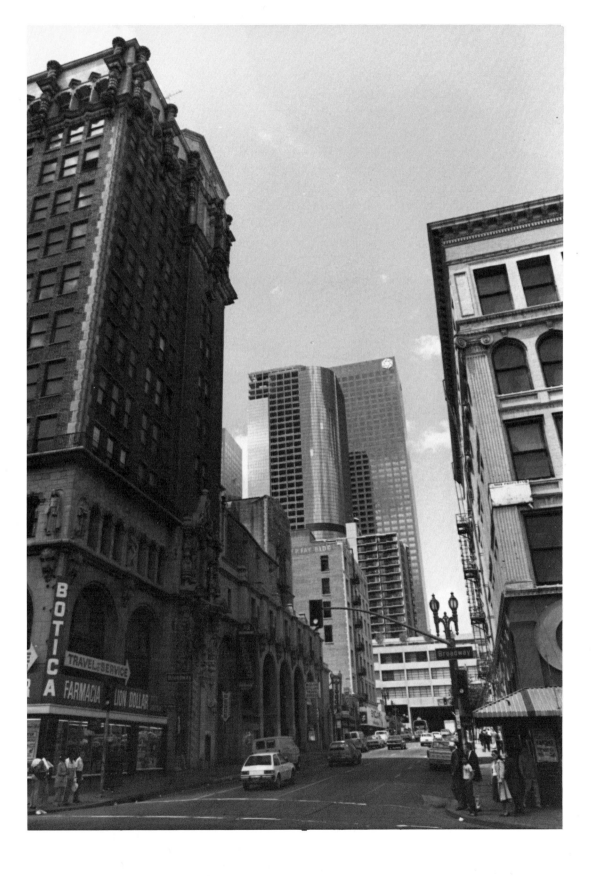

Just west of the Bradbury Building, Third Street goes through a tunnel at Hill. Above this tunnel is a modern apartment building, which seems rooted in the dark trench below. Above are Olive, Grand, and Hope streets, where some of the city's finest mansions and hotels once stood.

In 1901 Colonel J. W. Eddy built a funicular railroad called Angel's Flight. Its two fourteen-seat cable cars clambered up and down the hill until 1969. The Community Redevelopment Agency promised that the little railroad—which was, incidentally, the only profitable passenger line in operation in the entire United States at the time—would be restored intact by 1975. The two cars, custom built at a precise angle to ride the incline and named after the Biblical mountains Olivet and Sinai, are still sitting in a warehouse collecting dust.

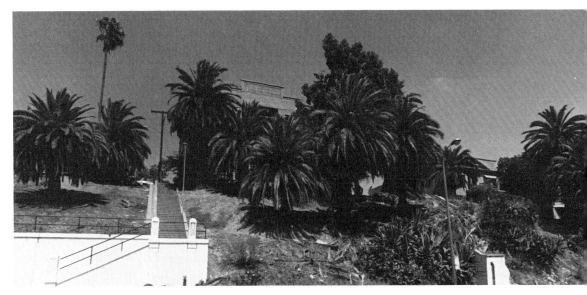

First Street Hill just west of Boylston Street.

It is difficult to visualize today, but Bunker Hill formed a solid wedge of land across the western side of the old L.A. pueblo. Because of it, some early settlers predicted that the city would never grow in a westerly direction. In 1867 developer Prudent Beaudry first laid out the hill as L.A.'s most exclusive residential area. Over the ensuing years it was reshaped many times until urban renewal bulldozed away all the existing history and landscape to bring modern architectural order and an authentic cultural situs to Los Angeles. The first of the projects to be completed in 1964 was the Music Center triad of buildings: the Dorothy Chandler Pavilion and the Ahmanson and Mark Taper theaters. They now preside like a modern Acropolis over downtown. Soon after, the tall, gray Bunker Hill luxury condos and apartment towers opened, to be followed in turn by the high-tech high rises, the Bonaventure Hotel and Security Pacific Plaza. Quite a bit of cleared land is still being used only for parking lots or weeds.

A survivor from the Bunker Hill area and several other Victorian (1870-1900) houses have been preserved at Heritage Square, established in 1974 by the Los Angeles Cultural Heritage Foundation. The structures, which include a railroad station from Palms and a church from Pasadena, have been saved from bulldozers, restored, repainted, and now stand in a row of antiquity at 3800 Homer Street just off the Pasadena Freeway. The buildings look a bit out of place sitting in a relatively unlandscaped arroyo. But if they were not here, they would be nowhere.

Beyond the Third Street tunnel, past Beaudry Street on the western side of the Harbor Freeway and north four blocks is a hill between First and Court streets. The neighborhood provides shelter for much the same sort of people, who live there for much the same reasons, as the denizens of the Old Bunker Hill that Chandler described. Along Angel's Flight, rickety steps cling to the exterior walls like existential stairways to oblivion. Such a location was a natural to be featured however briefly, in many *film noir*, most notably *Criss Cross, The Night Has a Thousand Eyes* and *Kiss Me Deadly*. The painter Millard Sheets captured this era and architecture in his exotic oils and watercolors. His 1931 painting "Angel's Flight" is permanently exhibited at the Los Angeles County Art Museum.

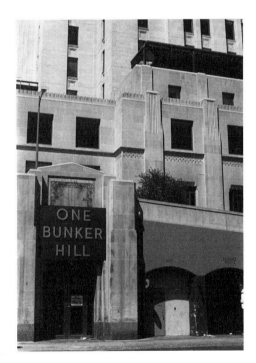

"One Bunker Hill" is actually at 5th and Grand.

Formerly known as the Edison Building, this Art Deco structure sits on a steep incline. The muraled lobby has recently been extensively restored.

12 / SECOND STREET TUNNEL

*M*ars flicked the Luger out again and pointed it at my chest. "Open the door."

The knob rattled and a voice called out. I didn't move. The muzzle of the Luger looked like the mouth of the Second Street tunnel, but I didn't move. Not being bullet proof is an idea I had had to get used to.

The Big Sleep

Second Street Tunnel looking west from Hill.

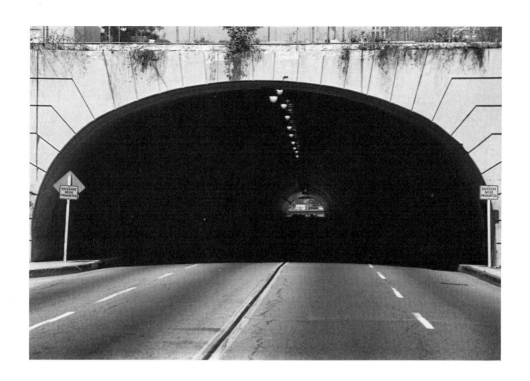

13 / WE'RE HEADED

"*We're headed,*" *I told Bernie Ohls. "Two guys got the kid's address there a while back. It might be —"*

Ohls grabbed the side of the car and swore as we took the corner on squealing tires. I bent forward over the wheel and drove hard. There was a red light at Central. I swerved into a corner service station, went through the pumps, popped out on Central and jostled through some traffic to make a right turn east again. . . .

Warehouses, a produce market, a big gas tank, more warehouses, railroad tracks, and two bridges dropped behind us. I beat three traffic signals by a hair and went right through a fourth. Six blocks on I got the siren from a motorcycle cop. Ohls passed me a bronze star and I flashed it out of the car, twisting it so the sun caught it. The siren stopped. The motorcycle kept right behind me for another dozen blocks, then sheered off.

Finger Man

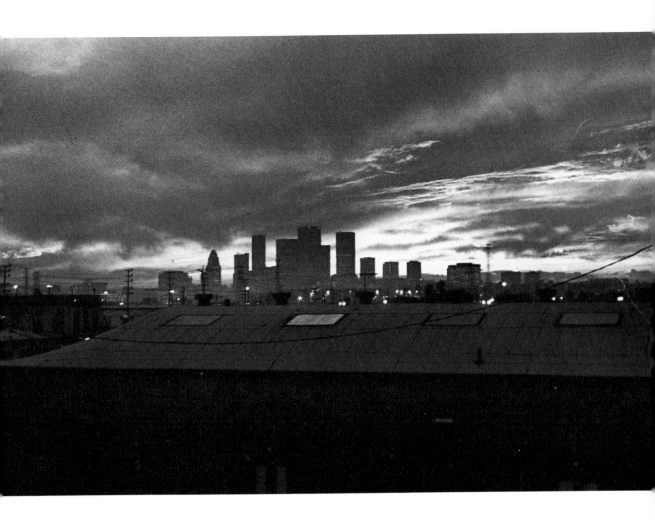

Rail lines heading south out of Union Station along Santa Fe Avenue.

The commuter train, like the one Chandler rode to La Jolla, still runs south out of downtown along these tracks—but far less frequently. West of the tracks are L.A.'s produce mart, garment district, and the edge of Skid Row.

14 / TRELOAR BUILDING

*T*he Treloar Building was, and is, on Olive Street, near Sixth, on the west side. The sidewalk in front of it had been built of black and white rubber blocks. They were taking them up now to give to the government, and a hatless pale man with a face like a building superintendent was watching the work and looking as if it was breaking his heart.

The Lady in the Lake

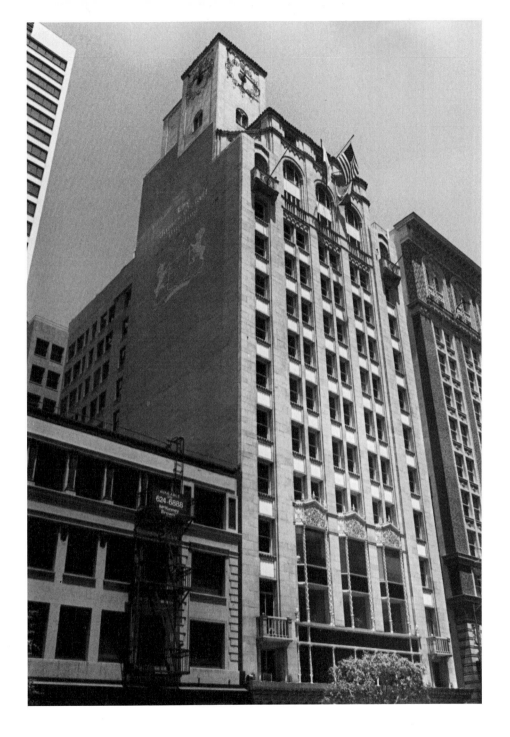

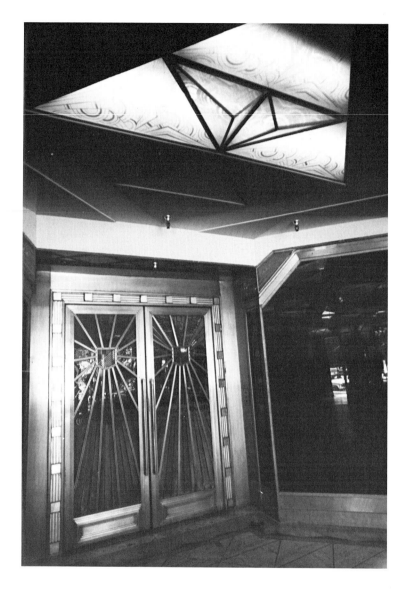

Chrome and glass foyer of Oviatt Building.

After businessman James Oviatt visited the 1925 Paris Exposition, he returned home to Los Angeles and commissioned the local architects Walker and Eisen to create an Art Deco design for a building that would house his exclusive men's haberdashery, several deluxe office suites, and a penthouse bungalow for himself. As a natural touch, the designers added to Oviatt's suite a swimming pool surrounded by real sand. The striking exterior entranceway of glass and a platinum-looking metal called "mallechort" was designed and manufactured by René[1] Lalique in Paris.

The building was beautifully restored in the mid-1970s. On the ground floor, the luxury restaurant Rex occupies what was once the elegant Oviatt and Alexander's Men's Store. The restaurant has kept many of the store's furnishings intact and uses the custom cabinets to display wines and desserts. The restaurant claims as its namesake the famous Italian luxury liner of the 1920s, *not* the gambling yacht that once floated in Santa Monica Bay and figured in Chandler's *Farewell, My Lovely* as the *Montecito* (see Excerpt 32).

15 / JESSE FLORIAN'S PLACE

1644 West 54th Place was a dried-out brown house with a dried-out brown lawn in front of it. There was a large bare patch around a tough-looking palm tree. On the porch stood one lonely wooden rocker, and the afternoon breeze made the unpruned shoots of last year's poinsettias tap-tap against the cracked stucco wall. A line of stiff yellowish half-washed clothes jittered on a rusty wire in the side yard. . . .

The bell didn't work so I rapped on the wooded margin of the screen door. Slow steps shuffled and the door opened and I was looking into the dimness at a blowsy woman who was blowing her nose as she opened the door. . . .

I said: "Mrs. Florian? Mrs. Jessie Florian?"

"Uh-huh," the voice dragged itself out of her throat like a sick man getting out of bed.

Farewell, My Lovely

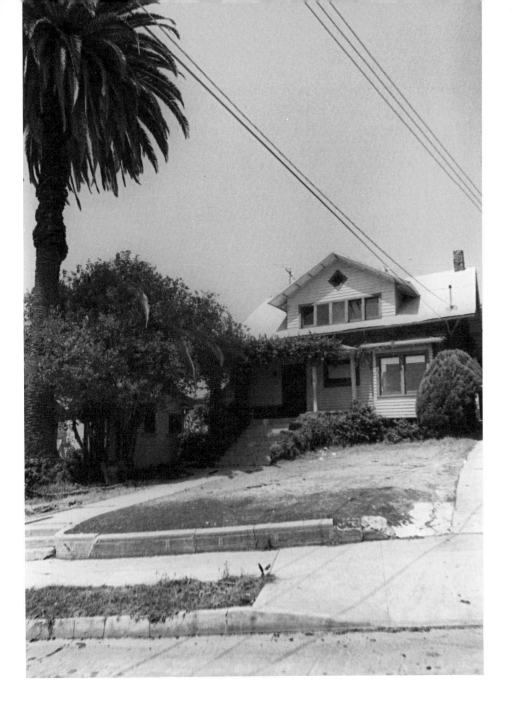

West 54th Street is south of downtown, in a neighborhood that has few resemblances to the street Chandler described. The Angelino Heights neighborhood is a community of a wide range of house styles and lifestyles. Many structures remain from the turn of the century. A row of well-restored Victorian houses is three blocks south along Carroll Avenue.

Poinsettias.

16 / GRAY LAKE

Gray Lake is an artificial reservoir in a cut between two groups of hills, on the east fringe of San Angelo. Narrow but expensively paved streets wind around in the hills, describing elaborate curves along their flanks for the benefit of a few cheap and scattered bungalows.

We plunged up into the hills, reading street signs on the run. The gray silk of the lake dropped away from us and the exhaust of the old Marmon roared between crumbling banks that shed dirt down on the unused sidewalks. Mongrel dogs quartered in the wild grass among the gopher holes.

Renfrew was almost at the top. Where it began there was a small neat bungalow in front of which a child in a diaper and nothing else fumbled around in a wire pen on a patch of lawn. Then there was a stretch without houses. Then there were two houses, then the road dropped, slipped in and out of sharp turns, went between banks high enough to put the whole street in shadow.

Then a gun roared around a bend ahead of us.

Ohls sat up sharply, said: "Oh-oh! That's no rabbit gun," slipped his service pistol out and unlatched the door on his side.

Finger Man

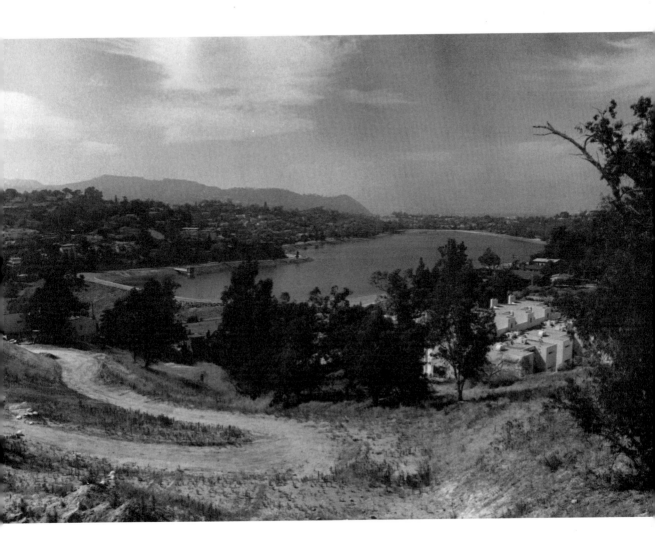

With his usual evocative cynicism, Chandler deglamorized the real estate developer's high-flown "Silver Lake." His just plain "Gray Lake" appears in "Finger Man" (and again in "Goldfish"), and it is the only time Chandler used the name "San Angelo" as an alias for The City of Angels.

The Silver Lake reservoir is a poor excuse for a watery view. City water reservoirs built later were often ringed with pine trees or bushes to camouflage the grim chain-link fences. Without such embellishment, Silver Lake seems imprisoned and guilty. Despite these drawbacks, many famous architects have done work in the hills surrounding Silver Lake and found ways to create unusual retreats for their clients, while still providing a decent view. One house, designed by John Lautner on Micheltorena Street, features a cantilevered swimming pool with a continuous edge of falling water that makes the pool and the lake below appear to be connected.

Chandler knew the Silver Lake area well. For a short time after his first brush with success as a writer, he lived at 1637 Redesdale in a nondescript bungalow. His 1936 short story "Goldfish" has Philip Marlowe discovering the body of Peeler Mardo in a Gray Lake duplex "on the second level, in a loop the street made rounding a spur of the hill," which is the actual geography of Chandler's residence.

Lower view of local enterprise.

17 / BRYSON TOWER APARTMENTS

*H*e *drove down to Wilshire and we turned east again.*

Twenty-five minutes brought us to the Bryson Tower, a white stucco palace with fretted lanterns in the forecourt and tall date palms. The entrance was in an L, up marble steps, through a Moorish archway, and over a lobby that was too big and a carpet that was too blue. Blue Ali Baba oil jars were dotted around, big enough to keep tigers in. There was a desk and a night clerk with one of those mustaches that get stuck under your fingernail.

Degarmo lunged past the desk towards an open elevator beside which a tired old man sat on a stool waiting for a customer. The clerk snapped at Degarmo's back like a terrier.

"One moment please. Whom did you wish to see?"

Degarmo spun on his heel and looked up at me wonderingly. "Did he say 'whom'?"

"Yeah, but don't hit him," I said. "There is such a word."

Degarmo licked his lips. "I knew there was," he said. "I often wondered where they kept it."

The Lady in the Lake

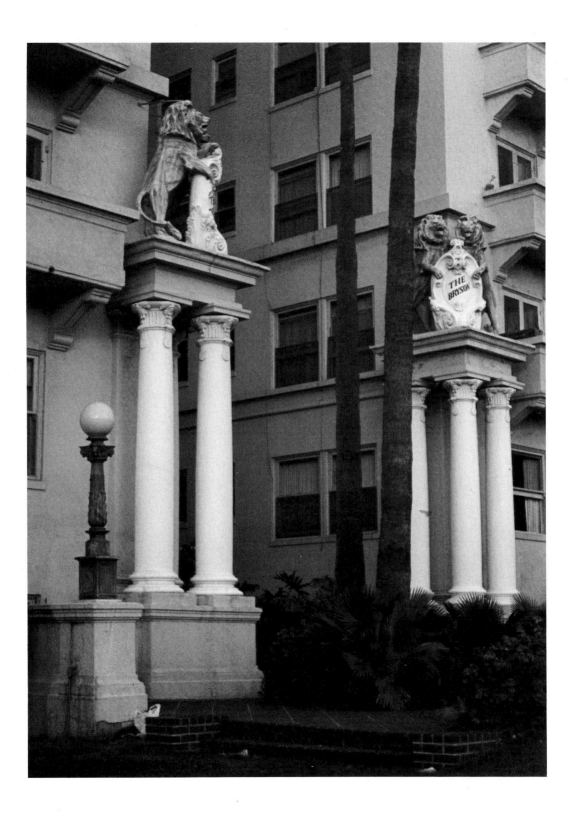

In 1932, at the age of forty four, Chandler was fired by the Dabney-Johnson Oil Corporation. Perhaps it was just the Depression that cost him his job; but other factors were his increasing and obvious boredom, his rumored affairs with secretaries, and the fact that he was finding alcohol more interesting than oil. At any rate, Chandler was not enthusiastic or hopeful about finding managerial work again, and nobody made any offers.

Although Chandler had always thought himself a writer, he also realized that almost everyone he met—especially after having a few drinks—thought of themselves as writers, too. Most of them shared Chandler's primary excuse for not writing, which was simply lack of time. Now that he was unemployed, Chandler had lost that excuse, but it was not as if he could afford to start a new career on a whim. He and his wife had saved little money. Although the Lloyd family was providing him with a hundred dollars a month, Chandler had to do something, so he started writing. The poetry and literary reviews he had produced for the English journals in his early twenties were not salable product, so Chandler set to work analyzing the writing market.

He practiced by imitating popular fiction. One of his early efforts, "The Sun Also Sneezes," anticipated by decades the Harry's Bar competition for Hemingway parodies. Chandler also mimicked the hard-boiled fiction of Dashiell Hammett and Erle Stanley Gardner. Chandler realized that he could not begin a new career by writing a promising first novel in middle age, so he decided that genre fiction and the pulps were the appropriate avenue to give him a chance to earn while he learned.

After *Black Mask* magazine paid him their basic rate of one cent per word or a total of $180 for "Blackmailers Don't Shoot," his first short story, Chandler later wrote that "he never looked back."[4]

Chandler wrote about this building as being near Bullock's Wilshire on Sunset Terrace, a street name that does not exist and should not be confused with Sunset Plaza Terrace near the Strip.

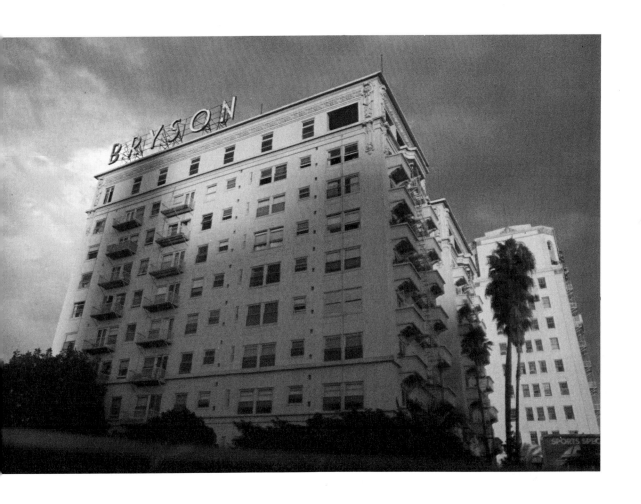

18 / BULLOCK'S GREEN-TINGED TOWER

"*Give me the money.*"

The motor of the gray Plymouth throbbed under her voice and the rain pounded above it. The violet light at the top of Bullock's green-tinged tower was far above us, serene and withdrawn from the dark, dripping city. Her black-gloved hand reached out and I put the bills in it. She bent over to count them under the dim light of the dash. A bag clicked open, clicked shut. She let a spent breath die on her lips. She leaned towards me.

"I'm leaving, copper. I'm on my way. This is a get-away stake and God how I need it. What happened to Harry?"

"I told you he ran away. Canino got wise to him somehow. Forget Harry. I've paid and I want my information."

"You'll get it. . . ."

The gray Plymouth moved forward, gathered speed, and darted around the corner on to Sunset Place. The sound of its motor died, and with it blonde Agnes wiped herself off the slate for good, so far as I was concerned. Three men dead, Geiger, Brody and Harry Jones, and the woman went riding off in the rain with my two hundred in her bag and not a mark on her.

The Big Sleep

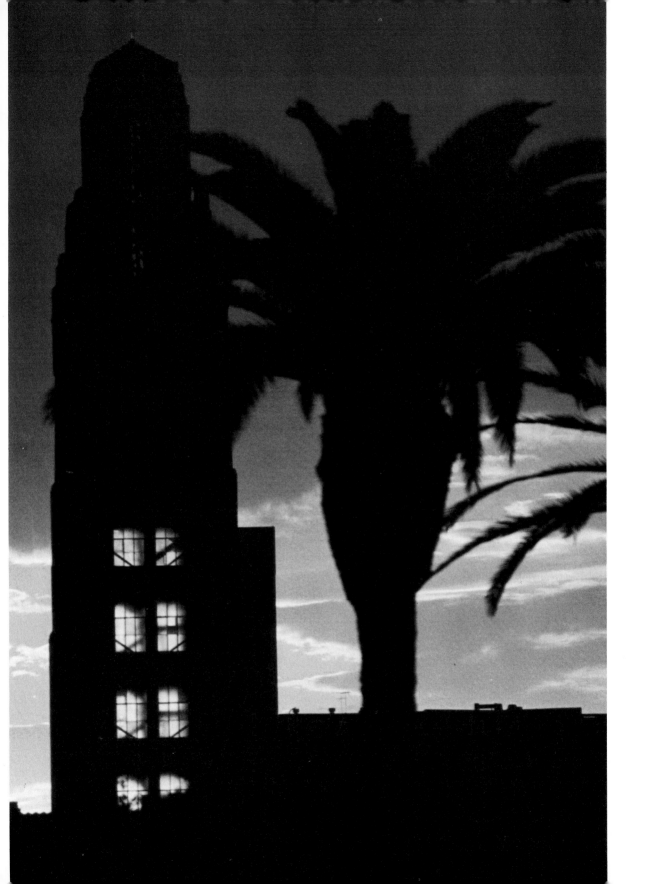

This extraordinary Art Deco building was the first "suburban" department store in the United States. John and Donald Parkinson were the architects for what has been called their masterpiece and what is still the "Flagship" store of Bullocks' Southern California mercantile empire. Even before Wilshire Boulevard was cut through MacArthur (then Westlake) Park to become the most prestigious business boulevard in the city, John Bullock put his new store close to the shoppers he desired. Sandwiched between Los Angeles's newest exclusive residential area, Hancock Park, and expensive mid-Wilshire apartments, it was completed just months before the 1929 stock market crash. Display windows and an impressive doorway face the Boulevard. The real entrance to this building, the first department store dedicated to the automobile-driving shopper, is off the parking lot, where a glassed-in porte-cochère features a ceiling mural by Herman Sacks depicting modes of "modern transportation" complete with a zeppelin. Unfortunately, the tower's "violet light" no longer shines.

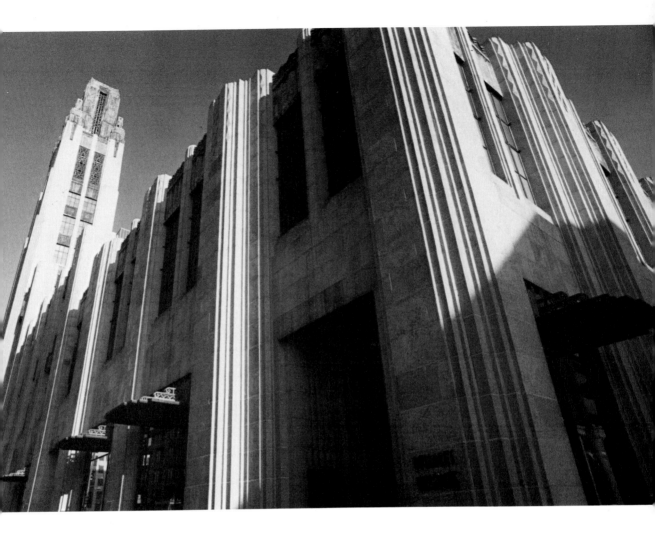

Bullock's Wilshire, 3050 Wilshire Boulevard.

19 / THE DEPARTMENT STORE STATE

*C*alifornia, the department-store state. The most of everything and the best of nothing.

The Little Sister

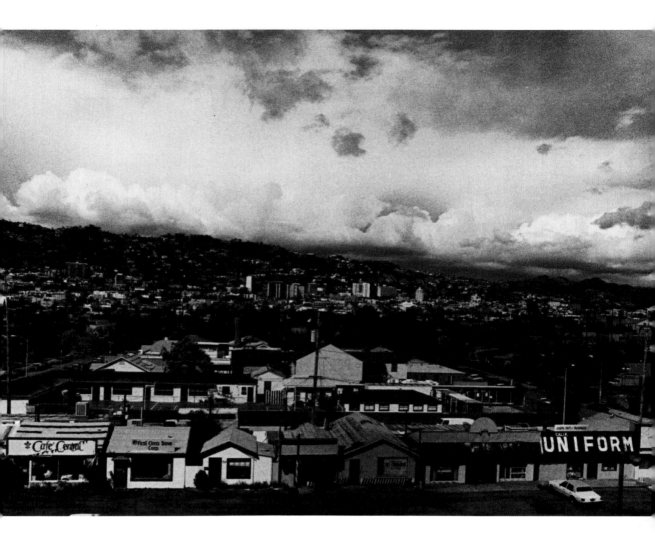

West Hollywood, looking north from the garage level of the Beverly Center at Beverly Boulevard and La Cienega.

20 / WONDERFUL WHAT HOLLYWOOD WILL DO

Wonderful what Hollywood will do to a nobody. It will make a radiant glamour queen out of a drab little wench who ought to be ironing a truck driver's shirts, a he-man hero with shining eyes and brilliant smile reeking of sexual charm out of some overgrown kid who was meant to go to work with a lunchbox. Out of a Texas car hop with the literacy of a character in a comic strip it will make an international courtesan, married six times to six millionaires and so blasé and decadent at the end of it that her idea of a thrill is to seduce a furniture-mover in a sweaty under shirt.

And by remote control it might even take a small-town prig like Orrin Quest and make an ice-pick murderer out of him in a matter of months, elevating his simple meanness into the classic sadism of the multiple killer.

The Little Sister

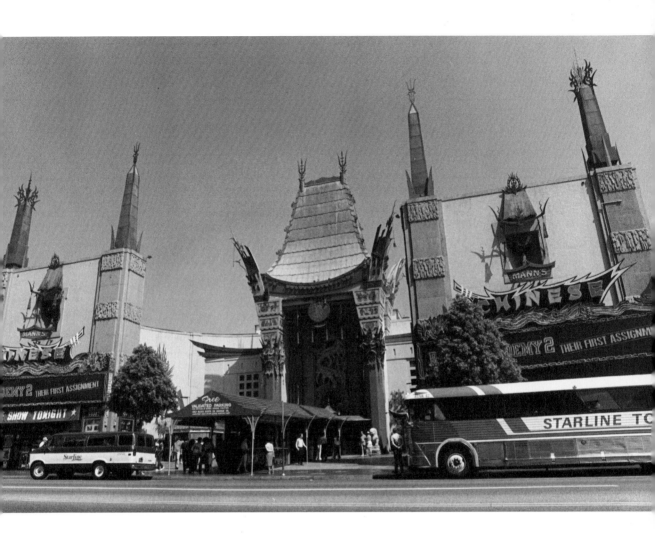

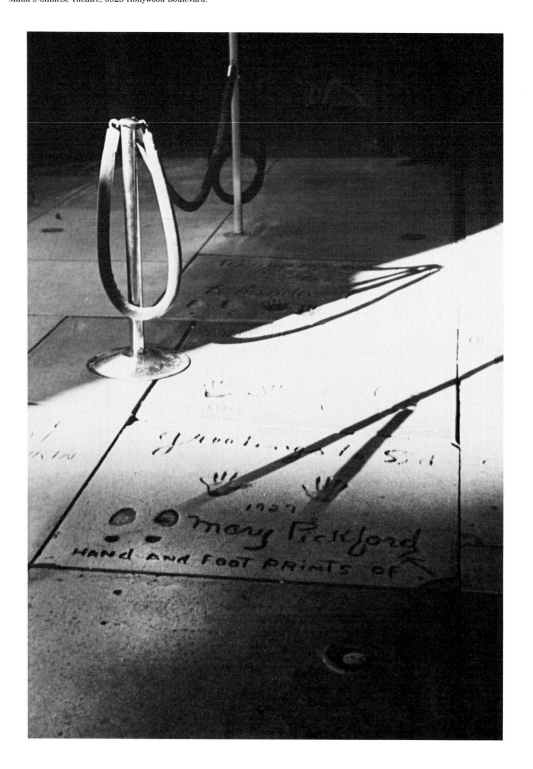

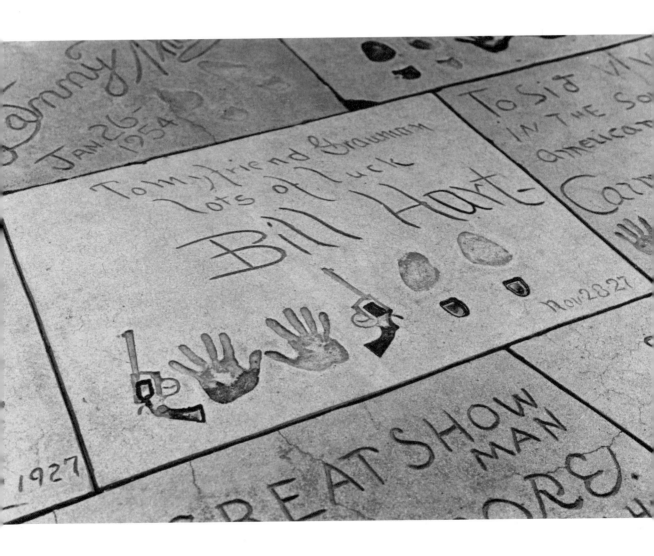

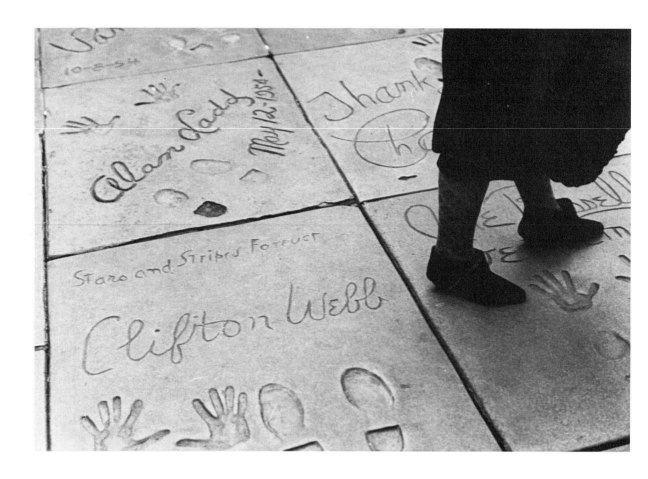

This mecca for movie worshipers was built by Sid Grauman after he had built the Million Dollar Theatre downtown and the Egyptian just a few blocks east; but the Chinese quickly became Sid's hallmark as a film exhibitor and showman. It opened in May 1927 with the premiere of Cecil B. DeMille's *King of Kings*.

Hollywood apochrypha records that the movie star footprints actually began when Sid was visiting the construction site and accidentally stepped in some wet concrete. A unique and inimitable gimmick was born. Sid invited his pals, Mary Pickford and Douglas Fairbanks, the reigning king and queen of movie stardom, to be the first to write their greetings to Sid in the forecourt of the finished theatre.

There were at last count 165 different versions of "Thanks Sid" and the accompanying footprints, handprints, legprints (Betty Grable), noseprints (John Barrymore), pawprints (Rin Tin Tin), and even a set of gunprints from the cowboy star William S. Hart. Tourists still flock to compare the caliber of their hands, feet, or whatever to those of the stars in this open-air courtyard.

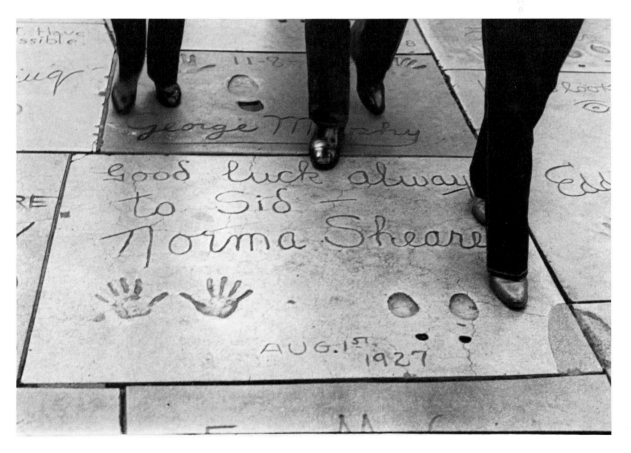

21 / RARE BOOKS AND DELUXE EDITIONS

A. *G. Geiger's place was a store frontage on the north side of the boulevard near Las Palmas. The entrance door was set far back in the middle and there was a copper trim on the windows, which were backed with Chinese screens, so I couldn't see into the store. There was a lot of oriental junk in the windows. I didn't know whether it was any good, not being a collector of antiques, except unpaid bills I let the door close softly behind me and walked on a thick blue rug that paved the floor from wall to wall A woman sat behind a small desk. . . .*

She got up slowly and swayed towards me in a tight black dress that didn't reflect any light. She had long thighs and walked with a certain something I hadn't often seen in bookstores In spite of her get-up she looked as if she would have a hall bedroom accent. . . .

"Was it something?" she enquired.

I had my horn-rimmed sunglasses on. I put my voice high and let a bird twitter in it. "Would you happen to have a Ben Hur 1860?"

She didn't say: "Huh?" but she wanted to. She smiled bleakly. "A first edition?"

"Third," I said. "The one with the erratum on page 116."

"I'm afraid not—at the moment."

"How about a Chevalier Audubon 1840—the full set, of course?"

"Er—not at the moment," she purred harshly. Her smile was now hanging by its teeth and eyebrows and wondering what it would hit when it dropped.

"You do *sell books?" I said in my polite falsetto.*

She looked me over. No smile now. Eyes medium to hard. Pose very straight and stiff. She waved silver fingernails at the glassed-in shelves. "What do they look like—grapefruit?" she enquired tartly.

The Big Sleep

Bennett's Book Shop, 6763 Hollywood Boulevard.

22 / MY DOG HOUSE

*B*ack in my dog house on the sixth floor of the Cahuenga Building I went through my regular double play with the morning mail. Mail slot to desk wastebasket. . .

The Long Goodbye

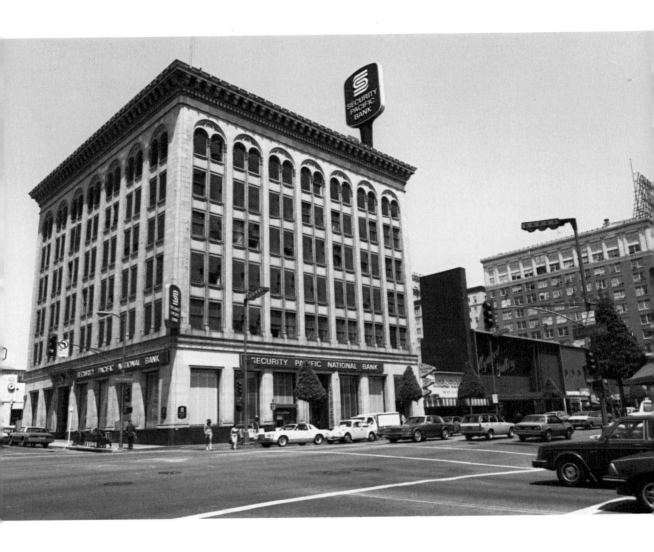

Hollywood is not really a city, just a postal designation for a part of Greater Los Angeles; but Hollywood was Marlowe's town. He lived there, ate most of his cheap meals there, and had his office on "the boulevard."

Chandler's Cahuenga Building was on "Hollywood Boulevard near Ivar." The Security Trust and Savings Bank, later known as the Cahuenga Building and now the Security Pacific Bank Building, was erected in 1921. When completed, this six-story structure by John and Donald Parkinson, who later designed Bullock's Wilshire and the Santa Monica City Hall (see Excerpts 18 and 31), was for a short time the tallest on the boulevard. Recently remodeled, it no longer has narrow corridors with pebbled glass window doors. From *Farewell, My Lovely* on, Marlowe has a parking space and an office on the sixth floor (number 615); but in *The Big Sleep* it's on the seventh floor, which the Parkinsons' building lacks.

One block east, at Hollywood and Ivar, is an alternate candidate for Marlowe's "dog house." The Beaux Arts Guaranty Building, now the Bank of America, by Austin and Ashley, was completed in 1923 and rose one hundred and fifty feet, the maximum then allowed in Los Angeles. (See Excerpt 2). If Marlowe had rented space here, he might have bumped into Hedda Hopper in the elevator. Marlowe sometimes went "down to the Mansion House Hotel" coffee shop to grab a bite. That could well be the Knickerbocker Hotel, just north on Ivar, where D. W. Griffith spent his last days.

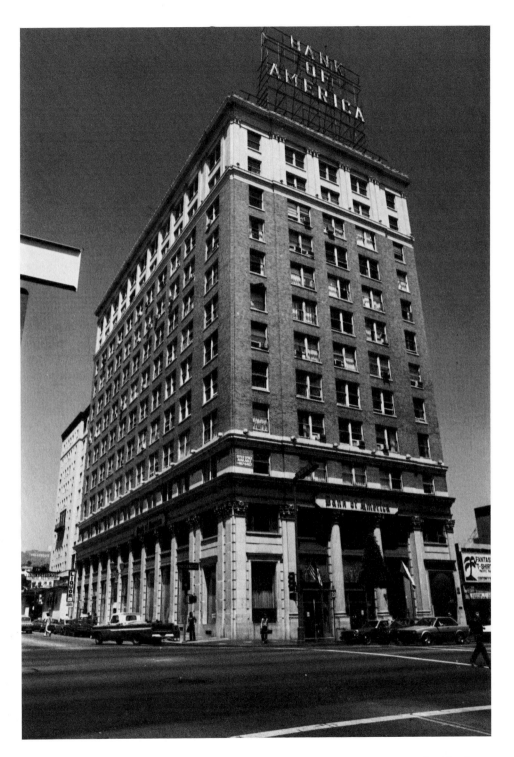

Guaranty Building at Hollywood Boulevard and Ivar Avenue.

23 / COME ON IN

*T*he *pebbled glass door panel is lettered in flaked black paint:* "Philip Marlowe
. . . Investigations." *It is a reasonably shabby door at the end of a reasonably shabby
corridor in the sort of building that was new about the year the all-tile bathroom
became the basis of civilization. The door is locked, but next to it is another door
with the same legend which is not locked. Come on in — there's nobody in here but
me and a big bluebottle fly. But not if you're from Manhattan, Kansas.*

The Little Sister

There are actually pebbled glass doors in Southern California on which Chandler devotees have lettered "Philip Marlowe, Investigations." Marlowe never left the Cahuenga Building, where he never had more than just "two small rooms at the back. One I left open for a patient client to sit in, if I had a patient client. . . . I looked into the reception room. It was empty of everything but dust" (*The High Window*). As early as "Finger Man," Marlowe had a habit of leaving the windows open, so that "the fringe of curtains was dirty and blowing about in the draft. There was a bar of late sunlight across my desk and it showed up the dust." Small wonder that by *The Little Sister* "the smell of old dust hung in the air as flat and stale as a football interview."

Marlowe's office may not have been "a clean, well-lighted place," but the light behind the door and transom at the end of this corridor seems an appropriate beacon for the troubled patrons who found their way to him. When Vivian Sternwood calls on him in *The Big Sleep*, Marlowe provides the fullest details of his office:

"*W*ell, you do get up," she said, wrinkling her nose at the faded red settee, the two odd, semi-easy chairs, the net curtains that needed laundering and the boy's size library table with the venerable magazines on it to give the place a professional touch. "I was beginning to think perhaps you worked in bed like Marcel Proust."

"Who's he?" I put a cigarette in my mouth. . . .

"A French writer, a connoisseur of degenerates. You wouldn't know him."

"Tut, tut," I said. "Come into my boudoir."

I unlocked the communicating door and held it for her. We went into the rest of my suite, which contained a rust-red carpet, not very young, five green filing cases, three of them full of California climate, an advertising calendar showing the Quints rolling around on a sky-blue floor, in pink dresses, with seal-brown hair and sharp black eyes as large as mammoth prunes. There were three near-walnut chairs, the usual desk with the usual blotter, pen set, ashtray and telephone, and the usual squeaky swivel chair behind it.

"You don't put on much of a front," she said.

Next year Marlowe was putting up more of a front. Instead of the Quints, his wall calendar was the reproduction of a Rembrandt self-portrait with eyes that may have been smaller than mammoth prunes but "were bright as drops of dew." (*Farewell, My Lovely*).

Marlowe jokes about having two business cards, one plain and one with a tommy gun in the corner that he gives to special customers. As for handguns, he uses several types. He began with a Luger autopistol, then used a .38 Colt Super Match automatic. In later years, he favored a Smith & Wesson .38 special with a four-inch barrel. On occasion, he "travels naked," as in *The Big Sleep* when he has to hold a pipe in his jacket pocket to intimidate Vivian Sternwood's assailant outside the Cypress Club. Later he uses the Derringer taken from her sister Carmen to get himself out of a jam.

Marlowe is likewise unconcerned with brands of automobiles, but the subject doesn't come up much. In *The Lady in the Lake* he simply drives a Chrysler. In *The Long Goodbye* he's got an Oldsmobile convertible. These are a step up from the 1925 Marmon touring car in "Finger Man;" but the Marlowe prototype in "Spanish Blood," the Hispanic cop, Delaguerra, drives a "dusty Cadillac."

Nobody ever seems to like the way Marlowe carries himself. Some clients, like Derace Kingsley, are forthright: "I don't like your manner." Marlowe's standard reply is, "That's all right. I'm not selling it." In *The Little Sister*, Marlowe is told he is not "talking nice" and answers, "Nothing I say is nice. I'm not nice." Marlowe does not volunteer much— as Vivian Sternwood observes, "You're the hardest to get anything out of. You don't even move your ears." It is because Marlowe is somewhat laconic that some clients, like Vivian's wealthy father, General Sternwood, take to Marlowe right away. Others sneer at him. Gangster Mendy Menendez calls him "Tarzan on a big red scooter."

Although he is occasionally offered less, Marlowe's fees are usually quoted at $25 a day plus expenses with eight cents a mile for his car. He doesn't enjoy bickering about it, so he gives in when Derace Kingsley says, "Absurd. Far too much. Fifteen a day flat. I'll pay the mileage. . . . but no joyriding." In *The Little Sister* Marlowe does know instinctively that he needs to ask Orfamay Quest for $40 a day in order to get $20. Sometimes, as in "Trouble Is My Business," he likes to make sure there is a "guarantee of two-fifty, if I pull the job." Also, as Marlowe informs Derace Kingsley, he may require a hundred dollars down from strangers as a retainer, especially from strangers he does not like much.

On the whole, Marlowe is fairly indifferent about money. In *The Long Goodbye*, he admits to Menendez that a single job has never netted more than "eight-fifty." Despite that, Marlowe will not take money from just anyone or do just anything. Some women are curious to know how there can be any profit in his business. Anne Riordan in *Farewell, My Lovely* asks if Marlowe makes enough to buy his own furniture. Later in the same book, Mrs. Grayle asks him if he's got "it." For once, she is not talking about sex. In *The Long Goodbye*, Marlowe tells Bernie Ohls that he keeps at it because "I'm a romantic. . . . I hear voices crying in the night and I go see what's the matter. . . . but no money, not a dime. I've

got a five-thousand dollar bill in my safe but I'll never spend a nickel of it. Because there was something wrong with the way I got it. I played with it a little at first and I still get it out once in a while to look at it. But that's all. . . . But I can always tell a cop to go to hell. Go to hell, Bernie.''

According to a letter Chandler wrote to a fan in 1951, Philip Marlowe was then ''somewhere near 38 years old.''[5] In *The Big Sleep*, published in 1939, Marlowe was already thirty-three. In *The Long Goodbye* (1954) Marlowe admits to being forty-two. Chandler may be uncertain as to his character's birthday, but he did reveal that Marlowe was raised in the small Northern California town of Santa Rosa. Marlowe was an only child; and both of his parents were already deceased by the time be began his detective career. The only significant detail from high school is that he played football, got a broken nose, and had an operation for a deviated septum. Marlowe had ''a couple of years'' of college at either the University of Oregon at Eugene or Oregon State University at Corvallis. Chandler claimed that he did not know why Marlowe came to Southern California, ''except that eventually most people do, although not all of them remain.''[6] Marlowe worked as a field investigator for an insurance company before becoming an investigator for Taggert Wilde, the L.A. district attorney, but he was never a regular cop. Chandler refused to divulge why Marlowe was fired by the D.A.'s office but hinted that Marlowe was ''too efficient at a time and in a place where efficiency was the last thing desired by the persons in charge.''[7] In *The Big Sleep*, Marlowe confesses that ''I test very high on insubordination.'' Marlowe does have a few influential people on the list of references he gives to Miss Davis, Mrs. Murdock's personal secretary, in *The High Window*. The list includes a state senator, a prominent city attorney, a bank vice-president, an important oil businessman, Bernie Ohls of the D.A.'s staff, and Detective-Lieutenant Carl Randall of the Central Homicide Bureau.

Chandler described Marlowe as ''slightly'' over six feet tall and weighing 190 pounds, with dark brown hair and brown eyes. He was careful to explain that Marlowe could be tough; but that he didn't look tough, that he was even perhaps a bit vain, as the novelist knew his character ''wouldn't be satisfied'' at being described simply as ''passably good looking.''[8] Marlowe disdains effete habits or gourmet affectations. He knows which fork to use, and that is about as far as he will go with social pretensions.

Marlowe's residential decor is as simple and functional as his office. He has the essentials and that's all he needs. He keeps his kitchen neat and uses it mostly to make good breakfasts and strong coffee, the drinking of which he calls taking a conference with ''Mr. Huggins and Mr. Young,'' a brand of coffee popular at the time. Otherwise, Marlowe eats out in restaurants if he has the time and appetite or just skips meals. He sleeps late whenever he can. In the early stories, Marlowe lived in a single apartment at the Berglund in Hollywood with a pull-down Murphy bed. In ''Finger Man,'' the detective checks out the Hobart Arms (see Excerpt 27). In *The Big Sleep*, Marlowe lives at a Hobart Arms on Franklin near Kenmore, which may be the same place. In *Farewell, My Lovely*, Marlowe may have moved into Joe

Brody's former digs on Randall Place. Having expired in *The Big Sleep*, Joe had no further use for the apartment, which had a separate bedroom, an ornamental balcony, and French windows, all for a rent of sixty dollars a month. In *The High Window* and *The Lady in the Lake*, Marlowe is ensconced at 1634 No. Bristol, which, if Bristol Avenue existed, would be just south of Hollywood Boulevard and quite convenient to his office. By *The Long Goodbye*, Marlowe had moved to a rented "house on Yucca Avenue in the Laurel Canyon district. It was a small hillside house on a dead-end street with a long flight of redwood steps to the front door and a grove of eucalyptus trees across the way. It was furnished, and it belonged to a woman who had gone to Idaho to live. . . . The rent was low, partly because the owner wanted to be able to come back on short notice, and partly because of the steps."

24 / NOT THE BRAINIEST

"*Hello,*" *I said.*

I was just talking to the office equipment, the three green filing cases, the threadbare piece of carpet, the customers' chair across from me, and the light fixture in the ceiling with three dead moths in it that had been there for at least six months. I was talking to the pebbled glass panel and the grimy woodwork and the pen set on the desk and the tired, tired telephone. I was talking to the scales on an alligator, the name of the alligator being Marlowe, a private detective in our thriving little community. Not the brainiest guy in the world, but cheap. He started out cheap and he ended cheaper still.

I reached down and put the bottle of Old Forester up on the desk. It was about a third full. . . . I took the cork out of the bottle. . . . and gave a sniff at it. I shuddered. That settled it. Any time I couldn't smell whiskey without shuddering I was through.

The Little Sister

Besides dust, the details Chandler picks out are not always the most appetizing. Except for the occasional insect remains, Marlowe keeps his office uncluttered and impersonal. He answers his own mail, makes his own telephone calls from Glenview 7537, and picks up his own dry cleaning when he has it. For diversion, Marlowe sometimes listens to the radio at home or in his car, but he never bothers to buy a television set, even when they start to get cheap. He goes out to movies only occasionally. He buys all the local papers. He does not discuss art, music, or literature unless some snob twists his arm; but he's not above reaching for some *bon mot* from Browning ("The poet, not the automatic") or Shakespeare.

Chandler and Joseph Conrad created two of modern literature's most long-winded narrators, both named Marlow(e); but Chandler may have been thinking of another Elizabethan, Christopher Marlowe, when he gave Philip a surname. Besides being a playwright, there is evidence that Christopher Marlowe was a secret agent for her majesty's government when he was murdered in a tavern brawl at the age of twenty-nine. Chandler's creation may be a literary descendant of Christopher, a modern private eye infused with chivalrous impulses, romantic notions, and a curious intellect inherited from a very different age. That may be in Linda Loring's mind when she quotes from *Dr. Faustus* in *The Long Goodbye*; but the only thing that Philip Marlowe will tell her about his name is that—unlike Conrad's guy— it's Marlowe with an 'e'."

Marlowe usually smokes Camels; but he doesn't insist on his brand and often uses a pipe. When he lights up his briar in front of Anne Riordan in *Farewell, My Lovely*, Marlowe is thinking to himself that she believes pipe smokers are solid men and that she will soon be disappointed. Chandler wrote that Marlowe was "not fussy about his alcohol either, unless it's sweet" and "certain drinks, such as pink ladies, Honolulu cocktails and creme de menthe highballs, he would regard as an insult."[9]

In *The Long Goodbye*, Marlowe admits to Mr. Spencer, a publisher, that he does "like liquor and women and chess and a few other things." At home he keeps a chessboard going with problems from a Leipzig manual or with exotic names like "The Sphynx" to distract him in idle moments. While chess is a mental challenge, liquor is sometimes a litmus test: "I took the cork out of the bottle of Old Forester and gave a sniff at it. I shuddered. That settled it. Anytime I couldn't smell whiskey without shuddering I was through." (*The Little Sister*)

Women are another story. Asked by General Sternwood why he is not married, Marlowe claims it is because he doesn't like policemen's wives. Some commentators (beginning in 1949 with Gershon Legman in *Love and Death: A Study in Censorship*) have asserted that Marlowe is gay and/or a masochist. Chandler dismissed such observations and countered, "Philip Marlowe, unlike myself (he is not me, of course), would get almost any woman into bed with him by . . . making a woman feel that you respect her."[10]

Marlowe likes deep, purring voices and butterfly kisses. He has no problem when Mrs. Grayle invites him to kiss her, and he doesn't seem to mind if Vivian Sternwood calls him

"beast" or "killer"; but he is no pushover. Types, like Vivian's sister, Carmen, who just decide to pop into his bed and wait until he comes home, are thrown out. Marlowe likes to be asked. While someone like Carmen causes Marlowe to tear up his bedsheets and remark that "women make me sick," someone like Anne Riordan, the cop's daughter, evokes an entirely opposite response. Despite Chandler's hint that it might be just a sexual ploy, Marlowe does respect women. In fact, Marlowe is, as Philip Durham first suggested when he dubbed him "Raymond Chandler's knight," almost chivalric in his outlook. As Marlowe remarks in *The Little Sister*, "You're going to find this hard to believe. But I came over with the quaint idea that you might be a girl who needed some help." As early as *The Big Sleep*, Marlowe is aware that his underlying attitude is somewhat at odds with his occupation, as per his ironic remarks on his chessboard: "Knights had no meaning in this game. It wasn't a game for Knights."

When Marlowe finally does get married it is to Linda Loring, the beautiful and sad sister of murdered Sylvia Lennox *and* the rich granddaughter of "Old Man" Harlan Potter. She twice asks Marlowe to marry her, once in *The Long Goodbye* and once in *Playback*, but he resists. Then suddenly, in the opening chapters of Chandler's unfinished "Poodle Springs Story," Mr. and Mrs. Marlowe have been married "three weeks and four days" and have returned from a quickie Mexican marriage to take up residence in a deluxe desert home. Marlowe plans to open a branch office in Palm Springs but promptly discovers that both the town law and the local mob think this is a bad idea.

Chandler only completed the first few chapters of this book, but he told friends that Marlowe's marriage wouldn't last. Perhaps he was anticipating that Marlowe would develop an antipathy for a resort with a moniker such as " 'Poodle Springs,' so named because every third elegant creature you see has at least one poodle."[11]

Chandler made it clear in many ways that Marlowe was no saint ("I've been in jail more than once") and that he has an individual code of ethics ("For one thing, I don't do divorce work"); but he wouldn't pigeonhole his character. He admitted some things ("He doesn't talk or behave like an idealist, but I think he is one at heart"[12]) but took exception to others ("As to his interest in women as 'frankly carnal,' these are your words, not mine"[13]). Some readers perceive Marlowe as an existential figure moving through "the big, dirty city" but keeping himself clean. For Chandler, Marlowe is a noble failure, a man with no money and no expectations. What Marlowe does have, beyond the cynical and hard-boiled talk, is an ideal and his self-respect. Perhaps this is where Marlowe and Chandler overlap most. Chandler conceded that "I don't mind Marlowe being a sentimentalist, because he always has been. The toughness has always been more or less a surface bluff."[14] After his wife died, Chandler confessed about himself, "All us tough guys are hopeless sentimentalists at heart."[15]

25 / WARM WEATHER

*I*t was getting dark outside now. The rushing sound of the traffic had died a little and the air from the open window, not yet cool from the night, had that tired end-of-the-day smell of dust, automobile exhaust, sunlight rising from hot walls and sidewalks, the remote smell of food in a thousand restaurants and perhaps, drifting down from the residential hills above Hollywood—if you had a nose like a hunting dog—a touch of that peculiar tomcat smell that eucalyptus trees give off in warm weather.

The High Window

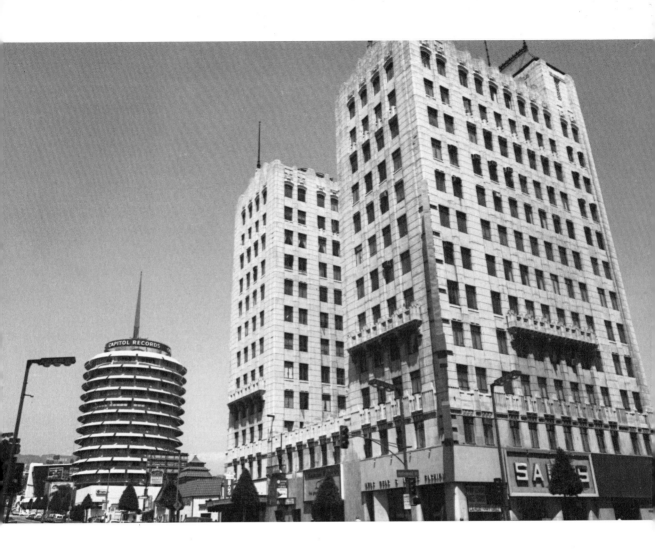

This famous corner is one block east of Marlowe's office at the self-proclaimed center of Hollywood.

The Capitol Records Building was built in 1954 by Welton Becket and Associates. It was purportedly the world's first circular office building and was unquestionably the first designed to look like a stack of 45 r.p.m. records with a stylus on top. The beacon on the stylus beams out "Hollywood" in morse code.

The Hollywood Equitable Building was built in 1929. Marlowe might have worked there when he was an insurance investigator.

Hollywood Boulevard and Vine Street.

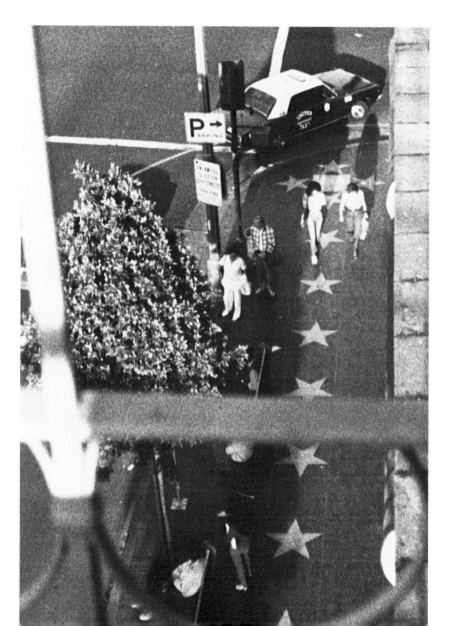

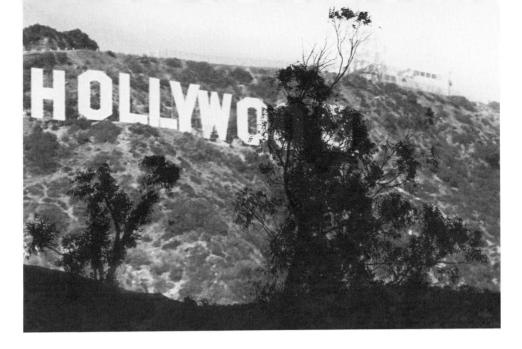

The Hollywood Sign and eucalyptus trees (double exposure).

The view is from a fire escape at the Hollywood Vine Plaza. This abandoned luxury department store from the late 1920s was recently converted into office space that isn't leasing.

Both sides of Hollywood Boulevard, and the two blocks south and north on Vine Street, are lined by a sidewalk that consists of coral and bronze stars set in black terrazzo squares. This is the Walk of Fame, begun in 1960 by the Hollywood Chamber of Commerce as part of a much needed face-lift. The Walk has grown in honorees and become part of a nonprofit Hollywood Historic Trust that takes itself very seriously and guards the myths of the great movie era. Over 1,800 of the 2,500 available stars have been "dedicated" to a particular celebrity whose name is set in the coral star with an insignia representing motion pictures, television, or radio in the star's center.

The Hollywood Sign was cheaply erected in 1923 as an advertisement for the "Hollywoodland" real estate development just below it in Beachwood Canyon. The first nine letters have survived a variety of assaults to become international symbols of the dream factory.

The Hollywoodland developers donated the letters to the city in the 1930s, and by the mid-1970s the sign was such a dilapidated eyesore that many of the hillside residents wanted to have it torn down. The Hollywood Chamber of Commerce mobilized movie fans and raised the money to refurbish the letters at a cost of $27,000 each, a sum reported to be ten times greater than the original cost of the entire sign.

Each letter is fifty feet high, so during the day, depending on the smog, the Hollywood Sign is visible from most points in the Los Angeles basin south of the Cahuenga Pass. The hillsides of Mt. Lee are extremely steep, but at night many still manage to get close enough to the letters to leave their marks with spray paint.

26 / A MAIL ORDER CITY

"*We've got the flash restaurants and night clubs . . . the riffraff of a big hard-boiled city with no more personality than a paper cup. . . . "*

"*It is the same in all big cities, amigo.*"

"*Real cities have something else, some individual bony structure under the muck. Los Angeles has Hollywood—and hates it. It ought to consider itself damn lucky. Without Hollywood it would be a mail order city. Everything in the catalogue you could get better somewhere else.*"

"*You are bitter tonight, amigo.*"

"*I've got a few troubles. The only reason I'm driving this car with you beside me is that I've got so much trouble a little more will seem like icing.*"

The Little Sister

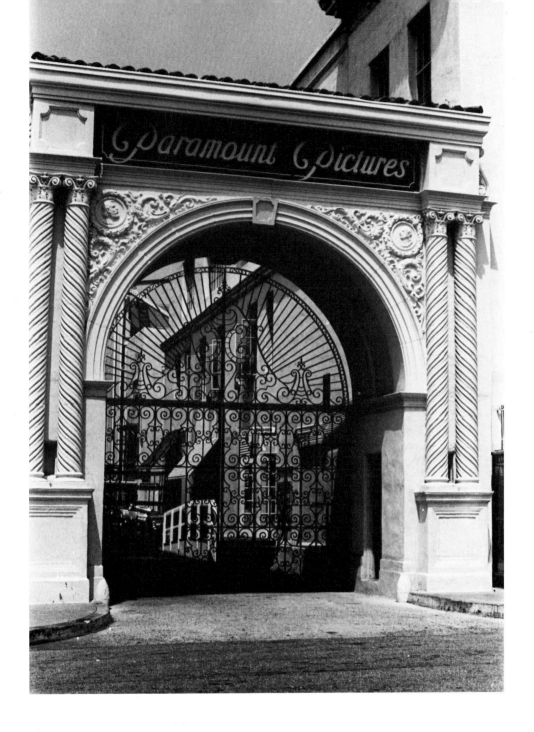

Paramount is the last of the Hollywood studios, the last major lot actually situated in Hollywood. In recent years, Western Street and the "B" tank have been turned into parking areas. New York Street burned down, and the main gate on Windsor has been shifted half a block east and widened. The Bronson Gate, however, is essentially unchanged from Chandler's day. Since this was the closest gate to the Writer's Building, it is likely that Chandler passed through it countless times on his way to Oblath's Restaurant, just across Marathon Street, which offered well-broiled steaks and well-chilled martinis.

One of the great ironies of Chandler's writing career is that he quit drinking after he lost his job with Dabney-Johnson Oil and stayed on the wagon through the years of writing penny-a-word short stories for the pulps. Even after the success of his early novels, Chandler was by no means wealthy; and Hollywood was just a town that he and Cissy had lived in and around for many years. It was the other Hollywood, the one that Chandler wrote "is easy to hate, easy to sneer at, easy to lampoon,"[16] that finally gave him financial independence and that literally drove him back to drink.

Chandler's first screenplays were done for Paramount; and in later years, he recalled the atmosphere there with a slight touch of fondness. He also produced scripts for MGM, Universal, and Warner Brothers, but his relationship with all his movie-company employers was always an uneasy one. There were two things he hated most about writing for motion pictures: collaborators and deadlines. When he got bored with adapting *The Lady in the Lake* for MGM, Chandler just stopped coming to the studio. His collaboration with Steve Fisher merely involved turning the material over to him, and eventually Chandler was sufficiently disenchanted with the project that he had his name removed from the film's credits. By the time he signed a contract with Universal for *Playback*, Chandler did not even want a studio office. He preferred working at home.

His first effort, coadapting James M. Cain's *Double Indemnity* with Billy Wilder for Paramount in 1943, seemed merely unpleasant to Chandler at the time. Although two of his novels had already been the basis of movies (see Filmography), Chandler was a Hollywood novice. He was offered the job only because Wilder's regular collaborator was busy on another picture and James M. Cain was working for a rival studio. Since he knew little about the format of screenwriting, Chandler was forced to defer to Wilder's greater experience and concentrated on writing dialogue. In fact, while Chandler would later grudgingly credit Wilder with teaching him the fundamentals of screenwriting, his personal antipathy for the director of *Double Indemnity* never diminished. Chandler found Wilder frivolous and arrogant in his working methods. Wilder, who had sold Paramount on the idea and had an understandably proprietary attitude toward the film, was reluctant to accept Chandler's suggestion that all the novella's dialogue be discarded. Eventually Chandler got Cain himself to back him and prevailed. Like Marlowe, Chandler's Walter Neff (Huff in Cain's book) likes to light matches with his thumbnail and crack wise.

From the first, Chandler had little patience with the rewrites, polishing, and punching

up, with the constant tinkering that is a Hollywood tradition. After *Double Indemnity*, he signed a contract with Paramount that paid well ($750 a week) but compelled daily attendance and regular hours. Chandler sold Paramount on adapting an unfinished novel of his, *The Blue Dahlia*, as the first project of his contract. Because it was to star Alan Ladd, who was to be called up soon to active duty in the army, production began before the script was finished. As the pressure mounted and Chandler reached the end of the existing storyline, he threatened to quit the project. Extraordinarily enough, Paramount agreed to let Chandler go home, go on a bender, and dictate the rest of the script to a crew of stenographers.

For Chandler the ideal arrangement, which he first proposed to Paramount, would have permitted him simply to deliver, at his own pace and for a flat fee, first-draft screenplays with which the studio could then do whatever it wished. Paramount's counter offer was to put Chandler on a weekly salary while he wrote scripts that he could produce and/or direct himself; but he had to do this according to a schedule. Chandler declined.

By the time he made the deal with Universal for *Playback*, Chandler had achieved a fair measure of the conditions he wanted; but he still found the process tedious and uninspiring. In an article for a national magazine, Chandler lamented that "the motion picture is a great industry, as well as a defeated art."[17]

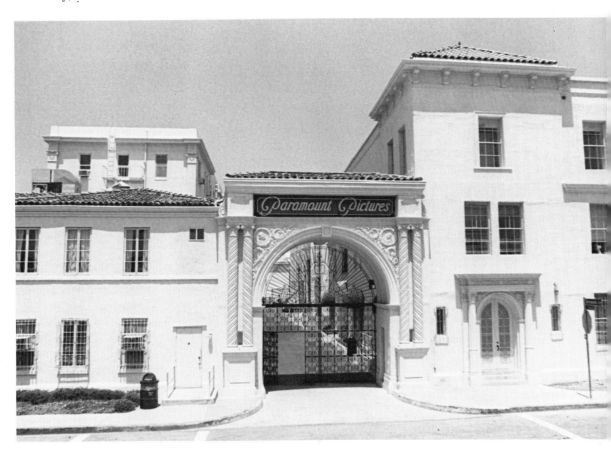

27/ THE HOBART ARMS

*T*he Hobart Arms was just another apartment house, in a block lined with them. It was six stories high and had a buff front. A lot of cars were at both curbs all along the block. I drove through slowly and looked things over. The neighborhood didn't have the look of having been excited about anything in the immediate past.

"Finger Man"

The Hobart Arms in "Finger Man" may have lacked some of the French curvilinear motifs; but from an investigator's point of view, the Hobart Arms or the El Milano ("Trouble is My Business") or the Tennyson Arms ("Bay City Blues") or the Chester Towers ("Pickup on Noon Street") or the Rossmore Arms (*The Lady in the Lake*) or the Chateau Bercy (*The Little Sister*) were all "just another apartment house." They were variously described as "a huge white stucco affair," "an old-fashioned dump," "a gloomy pile of dark red brick," or simply "old but made over." It was the people who lived and sometimes died inside that were of interest. Marlowe lived at a Hobart Arms in *The Big Sleep*, (see Excerpt 24), which featured a "square, barren lobby" where, despite being locked up at ten, there could be a "gunman waiting under the potted palm."

28 / NOT STRICTLY A BUNGALOW COURT

*T*wenty-four-twelve Renfrew was not strictly a bungalow court. It was a staggered row of six bungalows, all facing the same way, but so-arranged so that no two of their front entrances overlooked each other. There was a brick wall at the back and beyond the brick wall a church. There was a long smooth lawn, moon-silvered.

The door was up two steps, with lanterns on each side and an iron-work grill over the peep hole. This opened to his knock and a girl's face looked out, a small oval face with a cupid's-bow mouth, arched and plucked eyebrows, wavy brown hair. The eyes were like two fresh and shiny chestnuts.

The King in Yellow

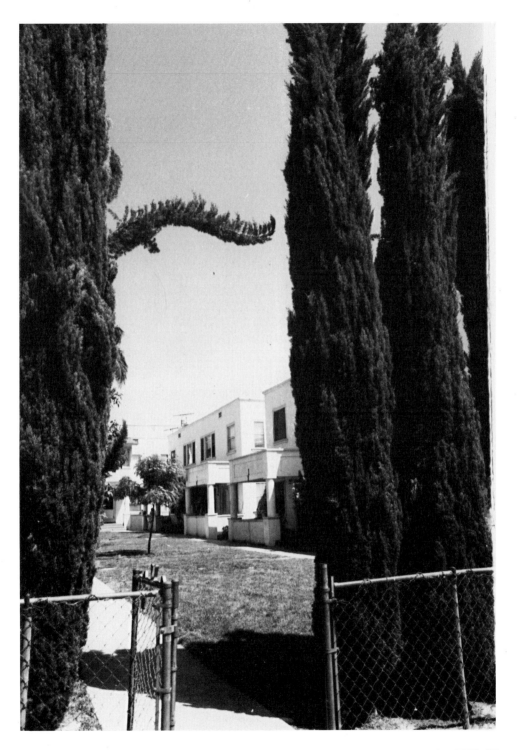

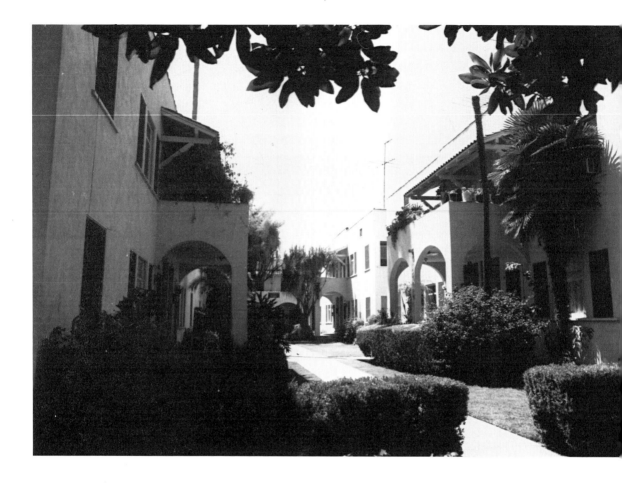

At least one of the tenants in any Hollywood bungalow court is likely to have a problem that calls for a private detective. Chandler never explains what a bungalow court strictly is. It may not be any of these court apartments, but the principle is the same: a compromise between privacy and cost. In fact, the California bungalow court is a richly varied phenomenon; but Chandler is probably referring to its earliest incarnation, a group of individual bungalows that shared a common garden area or courtyard in the center. Eventually, this evolved into a broader court concept, such as the Riness, in which the building shared walls as well as a central yard.

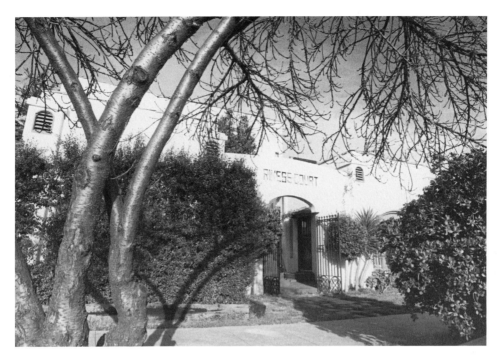

Riness Court Apartments, 17th Street, Santa Monica.

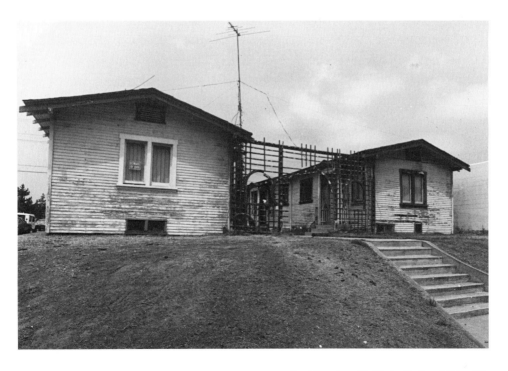

Court Bungalows, Washington Boulevard, Culver City.

29 / WE WENT WEST

*T*he car was a dark blue seven-passenger sedan, a Packard of the latest model, custom-built. It was the kind of car you wear your rope pearls in. . . . The Indian put me in the back. Sitting there alone I felt like a high-class corpse, laid out by an undertaker with a lot of good taste. . . .

We went west, dropped over to Sunset and slid fast and noiselessly along that. . . .

We curved through the bright mile or two of the Strip, past the antique shops with famous screen names on them, past the windows full of point lace and ancient pewter, past the gleaming new nightclubs with famous chefs and equally famous gambling rooms, run by polished graduates of the Purple Gang, past the Georgian-Colonial vogue, now old hat, past the handsome modernistic buildings in which the Hollywood flesh-peddlers never stop talking money, past a drive-in lunch which somehow didn't belong, even though the girls wore white silk blouses and drum majorettes' shakos and nothing below the hips but glazed kid Hessian boots. Past all this and down a wide smooth curve to the bridle path of Beverly Hills and lights to the south, all colors of the spectrum and crystal clear in an evening without fog, past the shadowed mansions up on the hills to the north, past Beverly Hills altogether and up into the twisting foothill boulevard and the sudden cool dusk and the drift of wind from the sea.

It had been a warm afternoon, but the heat was gone. We whipped past a distant cluster of lighted buildings and an endless series of lighted mansions, not too close to the road. We dipped down to skirt a huge green polo field with another equally huge practice field beside it, soared again to the top of a hill and swung mountainward up a steep hillroad of clean concrete that passed orange groves, some rich man's pet because this is not orange country, and then little by little the lighted windows of the millionaires' homes were gone and the road narrowed and this was Stillwood Heights.

The smell of sage drifted up from a canyon and made me think of a dead man and a moonless sky.

Farewell, My Lovely

Sunset Boulevard looking west from La Cienega.

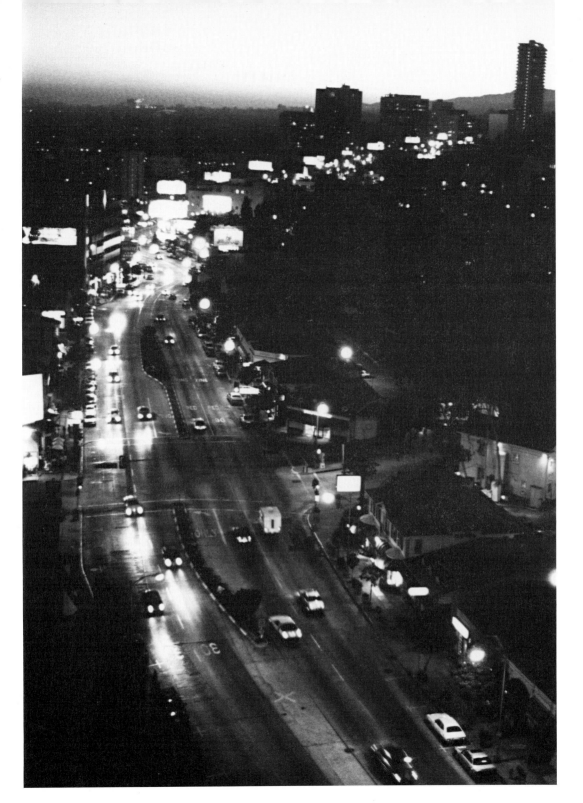

Marlowe was often chauffeured to places that he would never have chosen to visit, as when Amthor requests the detective's presence at his "Eyrie" in Stillwood Heights, which was Chandler's sinister name for the coastal area known as Pacific Palisades.

Driving all the way out to the beach on Sunset Boulevard is like riding an asphalt river through the foothills to the ocean. The well-traveled road curves westward starting downtown from Union Station through districts with such idyllic names as Elysian Park, Silver Lake, and Bel Air. Along the way to the sea, it neatly bisects both the tattered glamor of Hollywood and the understated elegance of Beverly Hills. Between these two celebrated cities, at just about its midpoint, Sunset Boulevard becomes the Strip.

Nightclub style in Chandler's day was nothing if not ecletic, to wit: "The high foyer [was] walled with milky glass lighted softly from behind. Molded in the glass were etchings of sailing ships, beasts of the jungle, Siamese pagodas, temples of Yucatan. The doors were square frames of chromium, like photo frames. The Club Shalotte had all the class there was." ("The King in Yellow"). There may still be nightclubs of Chandler's description somewhere in Los Angeles, but they aren't on the Sunset Strip. The Clover Club, the Mocambo, the Trocadero—all are gone, transformed into record shops, parking lots, or dry cleaners.

What's left on the Strip is institutional burlesque from the 1950s like The Body Shop and the one authentic rock joint, Gazarri's. The Whiskey-a-Go-Go is gone-gone, a marquee for rent. The Roxy has painted itself pastel pink in a showdown of Neonuclear Deco with Glitter, the current hot spot tying up traffic that is mostly cruisers from the Valley. What does seem to be "in" on the Strip now is sitting at Spago Restaurant and looking out over the landscape of movie billboards and music ads.

Just beyond newly-incorporated West Hollywood, past the discreet, shield-shaped sign that signals the border of Beverly Hills, there is a parkway in the center of the boulevard, which was originally a bridlepath. Up through the early twenties, this was the final link in the trail that an ambitious rider could follow from the Biltmore downtown to the Beverly Hills Hotel (see Excerpt 1).

The polo field that Marlowe saw on his ride out to Amthor's is the one on the Will Rogers estate, which is now a state park and open to the public. In 1947 the Chandlers lived right around the bend from Will Rogers's polo field at 857 Iliff Street. It is a neighborhood of tiny but tidy homes just off the boulevard and close to the "village" shopping area.

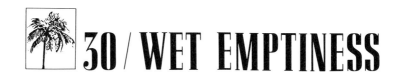

30 / WET EMPTINESS

*W*e drove away . . . through a series of little dank beach towns with shack-like houses built down on the sand close to the rumble of the surf and larger houses built back on the slopes behind. A yellow window shone here and there, but most of the houses were dark. A smell of kelp came in off the water and lay on the fog. The tires sang on the moist concrete of the boulevard. The world was a wet emptiness. . . .

"Drive down by the Del Rey beach club. I want to look at the water. It's the next street on the left."

There was a winking yellow light at the intersection. I turned the car and slid down a slope with a high bluff on one side, interurban tracks to the right, a low straggle of light far off beyond the tracks, and then very far off a glitter of pier lights and a haze in the sky over a city. That way the fog was almost gone. . . .

I braked the car against the curb and switched the headlights off and sat with my hands on the wheel. Under the thinning fog the surf curled and creamed, almost without sound, like a thought trying to form itself on the edge of consciousness.

"Move closer," she said almost thickly.

The Big Sleep

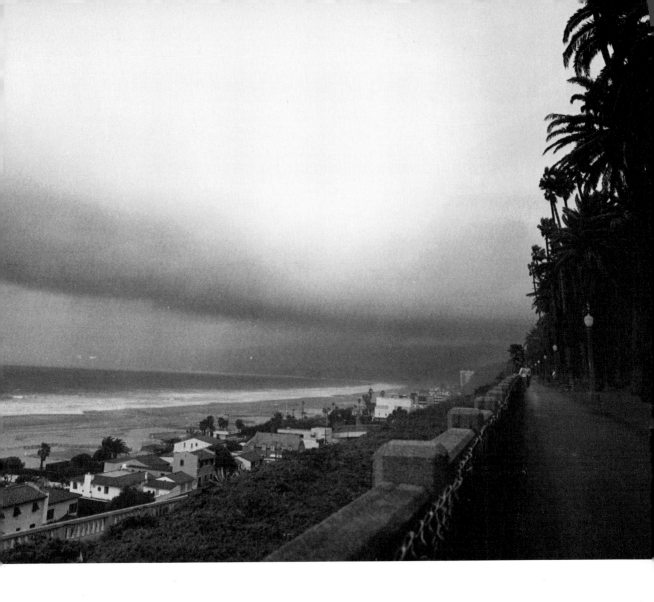

In 1875 a cattleman, Colonel R. S. Baker, and John P. Jones, a millionaire from the Comstock Lode, became partners in founding the city of Santa Monica. Together they dreamed of building a port for Los Angeles. Meanwhile, they laid out large residential and business districts. They also set aside the massive but geographically unstable bluff, known as the Palisades, as a public park. About twenty yards wide, it stretches almost three miles from the municipal pier to the mouth of the Santa Monica canyon.

The Bel Air Bay Club, 16801 Pacific Coast Highway.

The 1927 prospectus for the Bel Air Bay Club offered would-be members an opportunity to buy one of sixty-seven cottage sites in Castellammare, arrayed around a Spanish-style main building and having access to a private beach via a passageway under the coast highway. Of course, initial participation was limited to those persons who had both the wherewithal and the pedigree. There are similar private clubs along Santa Monica Beach below the Palisades, such as the Sand and Sea and the Jonathan. The latter has recently been heavily criticized for its ''restricted'' policy on new members.

31 / A LITTLE TROUBLE

*I*t was a cheap looking building for so prosperous a town. It looked more like something out of the Bible belt.

The cracked walk and the front steps led to open double doors in which a knot of obvious city hall fixtures hung around waiting for something to happen so they could make something else out of it. They all had the well-fed stomachs, the careful eyes, the nice clothes and the reach-me-down manners. They gave me about four inches to get in.

Inside was a long dark hallway that had been mopped the day McKinley was inaugurated.

The second floor was lighter and cleaner but that didn't mean it was clean and light. A door on the ocean side, almost at the end of the hall was lettered: John Wax, Chief of Police. Enter. . . .

"Sit down, Mr. Marlowe. I see you are in our business more or less. What can I do for you?"

"A little trouble, Chief. You can straighten it out for me in a minute, if you care to."

"Trouble," he said softly. "A little trouble . . . is something our little city doesn't know much about, Mr. Marlowe. Our city is small but very, very clean. I look out of my western windows and I see the Pacific Ocean. Nothing cleaner than that, is there?" He didn't mention the two gambling ships that were hull down on the brass waves just beyond the three-mile limit . . .

He threw his chest a couple of inches farther. "I look out of my northern windows and I see the busy bustle of Arguello Boulevard and the lovely California foothills, and in the near foreground one of the nicest little business sections a man could want to know. I look out of my southern windows, which I am looking out of right now, and I see the finest little yacht harbor in the world, for a small yacht harbor. I don't have no eastern windows, but if I did have, I would see a residential section that would make your mouth water. No, sir, trouble is a thing we don't have a lot of on hand in our little town."

"I guess I brought mine with me, Chief. Some of it at least."

Farewell, My Lovely

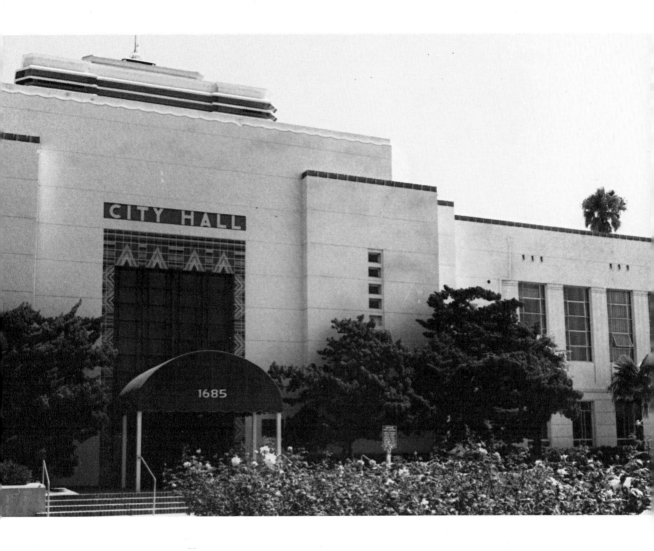

This squat combination of Streamline Moderne and California Mission style was built by architects Donald B. Parkinson and J. M. Estep in 1939. The Moderne facade supports a square cupola, and the tiled entrance opens onto a muraled lobby that features several idealized panels on Santa Monica history.

Santa Monica skyline as seen from the pier.

The tall buildings herald the intersection of Wilshire Boulevard and Ocean Avenue. Champagne music master Lawrence Welk built the office high rise designed by Cesar Pelli and the Wilshire West Apartments in 1973. The terraced Wilshire Professional Building was built in 1980. Some of the ramshackle beachfront homes still left strewn on the sand are from the 1870s.

San Vicente Boulevard.

This residential section is well-traveled by BMWs and Reeboks. The parkway is lined with coral trees, which in February produce large, bright red blossoms perched on bare and graceful branches.

Chandler referred to it as "Descanso Street" in *Farewell, My Lovely* and placed Dr. Sonderborg's sanitarium at the corner of 23rd Street. Marlowe is kept doped up and imprisoned inside "an old house, built as once they built them and don't build them any more. Standing probably on a quiet street with a rose arbor at the side and plenty of flowers in front. Gracious and cool and quiet in the bright California Sun. And inside it who cares, but don't let them scream too loud."

Chandler and Cissy resided briefly in an apartment near the Pacific at 449 San Vicente. Chandler used that street number in *The Little Sister* (see Excerpt 35).

32 / BAY CITY IS
A NICE TOWN

"*It's a nice town,*" *she said sharply, a little breathlessly.* "*You can't judge —*"

"*Okey, it's a nice town. So is Chicago. You could live there a long time and not see a Tommygun. Sure, it's a nice town. It's probably no crookeder than Los Angeles. But you can only buy a piece of a big city. You can buy a town this size all complete, with the original box and tissue paper. That's the difference. And that makes me want out. . . .*"

"*In Bay City,*" *he said slowly.*
"*The name's like a song. A song in a dirty bathtub.*"

Farewell, My Lovely

Bay City was the end of the line for Marlowe's Los Angeles. It was the last stop of the interurban trains, the end of the western track. North up the coast was Malibu, where movie stars hid in their grandiose shacks on the sand. To a certain extent, Bay City was Chandler's amalgamation of all the beach towns that string along Pacific Coast Highway like pearls down the long neck of the ocean, but not as nice. The highway itself runs from Malibu past Santa Monica and around the golden horn of the Palos Verdes Peninsula, where it turns to cut through the industry-choked docks of San Pedro and Long Beach.

For the most part, Bay City, where the cops squirmed from being too close to money and from not having enough of it themselves, was simply Santa Monica. During prohibition and throughout the 1930s Santa Monica was considered an open town. The corruption and vice was well documented; and stories about it sold a lot of newspapers until the town began to clean itself up in the late 1940s.

One of the first casualties of the reformers' wrath was the gambling ship out in the harbor. In *Farewell, My Lovely*, Chandler wrote that there were two ships, the *Montecito* and the *Royal Crown*, moored near each other. In reality, the area's second floating casino was off San Pedro, several miles to the south. The ship five miles out in Santa Monica Bay was the *Rex*, owned by Tony Cornero, gambler and businessman.

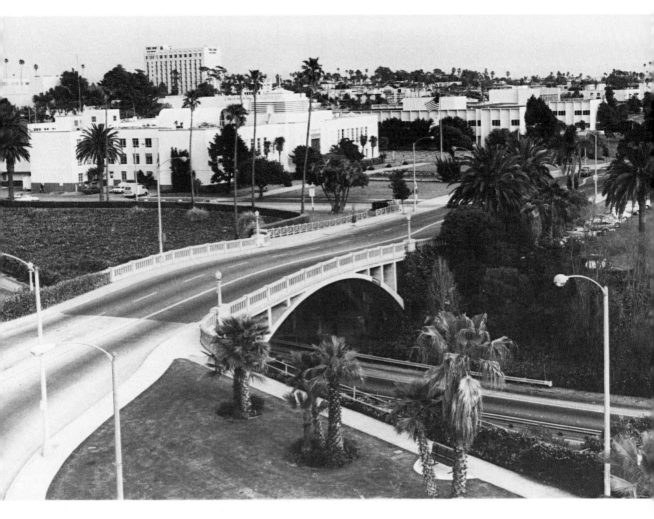

Santa Monica Civic Center.

33/A SPECIAL BRAND OF SUNSHINE

*I*t *was close to the ocean and you could feel the ocean in the air but you couldn't see water from the front of the place. Aster Drive had a long smooth curve there and the houses on the inland side were just nice houses, but on the canyon side they were great silent estates, with twelve foot walls and wrought-iron gates and ornamental hedges; and inside, if you could get inside, a special brand of sunshine, very quiet, put up in noise-proof containers just for the upper classes. . . .*

The house itself was not so much. It was smaller than Buckingham Palace, rather gray for California, and probably had fewer windows than the Chrysler Building.

Farewell, My Lovely

Walled estate, Southern California.

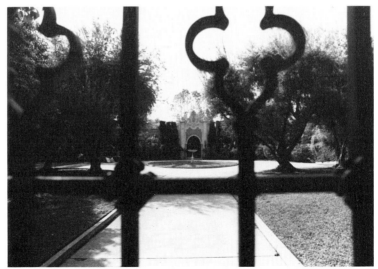

34 / SANCTUARY

*I*t was a cool, moist night, no moon.

The sign on the corner said Descanso Street. Houses were lighted down the block. I listened for sirens. None came. The other sign said Twenty-third Street. I plowed over to Twenty-fifth Street and started towards the eight-hundred block. No. 819 was Anne Riordan's number. Sanctuary.

I had walked a long time before I realized that I was still holding the gun in my hand. And I had heard no sirens.

I kept on walking. The air did me good, but the whiskey was dying, and it writhed as it died. The block had fir trees along it, and brick houses, and looked like Capitol Hill in Seattle more than Southern California.

There was a light still in No. 819. It had a white porte-cochère, very tiny, pressed against a tall cypress hedge. There were rose bushes in front of the house. I went up the walk. I listened before I pushed the bell. Still no sirens wailing . . .

The door opened wide. . . . Her face under the glare of the porchlight was suddenly pale.

"My God," she wailed. "You look like Hamlet's father!"

Farewell, My Lovely

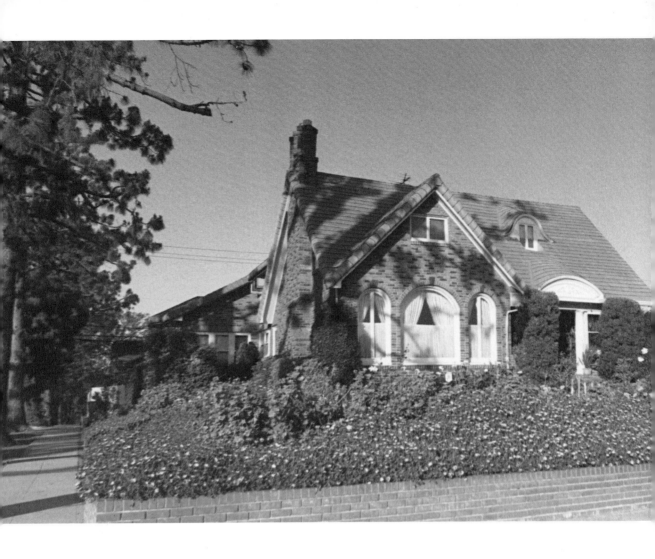

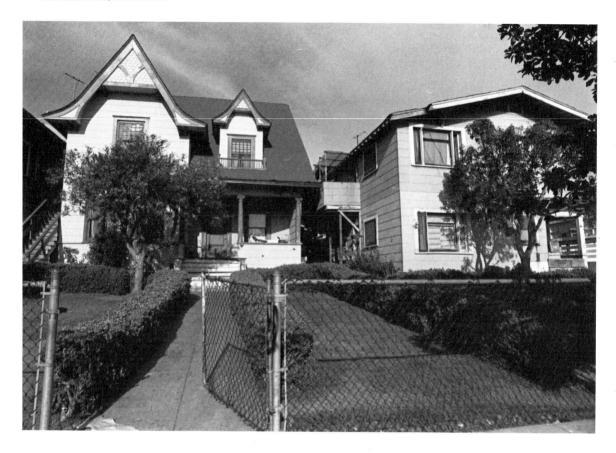

Frame house, Santa Monica.

Of all the girls that Marlowe meets, Anne Riordan is the nicest. He feels she ought to steer clear of the likes of him and connect with some true-blue cop, one who could still tell the difference between right and wrong from fifty paces. Of course, he never bothers to ask for her opinion on the matter.

Chandler situates Anne Riordan's house at 819 25th Street, an address that is now a condominium. But this brick house, a bit northeast and closer to San Vicente, also fits the description of Anne's house from ''The Pencil:'' a ''house as neat as a fresh pinafore.''

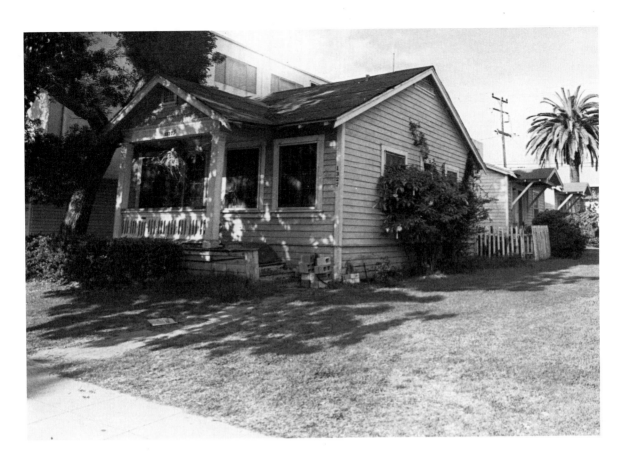

The Queen Anne house in the following excerpts was built just before the turn of the century and is typical of the structures that were converted to rooming houses as the population on the west side of the L.A. basin grew. It was moved to its current site from Wilshire Boulevard in 1924, has lately been refurbished, and now houses a doll and toy museum to benefit autistic children.

Santa Monica has its own Heritage Square at Main Street and Ocean Park Avenue, established in 1977. The Jones house, built for the son of Santa Monica's cofounder by Sumner Hunt in 1894, is a Queen Anne-Colonial, the restoration of which includes a bookstore and room exhibits. Adjacent is the 1903 Trask House, which now houses a restaurant.

The California Historical Society conducts walking tours of the beach communities around Santa Monica Bay.

*Y*ou could know Bay City a long time without knowing Idaho Street. And you could know a lot of Idaho Street without knowing Number 449. The block in front of it had a broken paving that had almost gone back to dirt. The warped fence of a lumberyard bordered the cracked sidewalk on the opposite side of the street. Half-way up the block the rusted rails of a spur track turned in to a pair of high, chained wooden gates that seem not to have been opened for twenty years. . . .

Number 449 had a shallow, paintless front porch on which five wood and cane rockers loafed dissolutely, held together with wire and the moisture of the beach air. The green shades over the lower windows of the houses were two-thirds down and full of cracks. Beside the front door there was a large printed sign, "No Vacancies." That had been there a long time too. It had got faded and fly-specked. . . .

I pushed the bell. It rang somewhere near by but nothing happened. I rang it again. The same nothing happened. I prowled along to a door with a black and white metal sign on it — "Manager." I knocked on that. Then I kicked it. Nobody seemed to mind my kicking it.

The Little Sister

Queen Anne House, Colorado Street, Santa Monica.

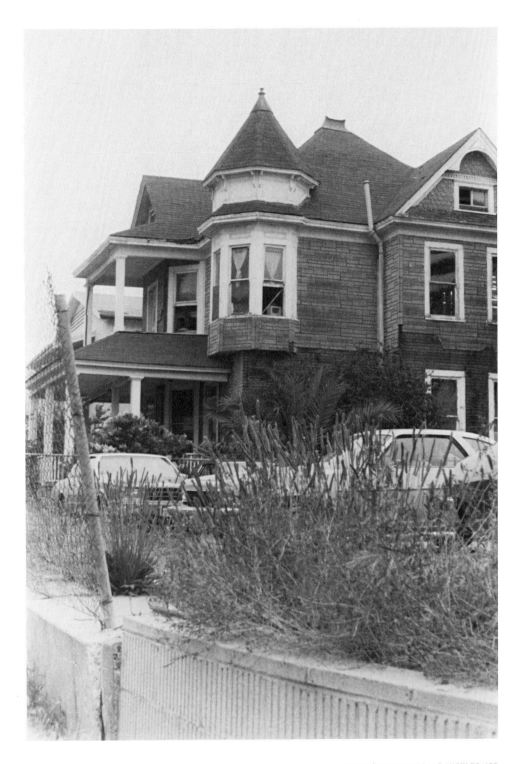

36 / OUTSIDE

Outside the narrow street fumed, the sidewalks swarmed with fat stomachs. Across the street a bingo parlor was going full blast and beside it a couple of sailors with girls were coming out of a photographer's shop where they had probably been having their photos taken riding on camels. The voice of the hot dog merchant split the dusk like an axe. A big blue bus blared down the street to the little circle where the street car used to turn on a turntable. I walked that way.

After a while there was a faint smell of ocean. Not very much, but as if they had kept this much just to remind people this had once been a clean open beach where the waves came in and creamed and the wind blew and you could smell something besides hot fat and cold sweat.

Farewell, My Lovely

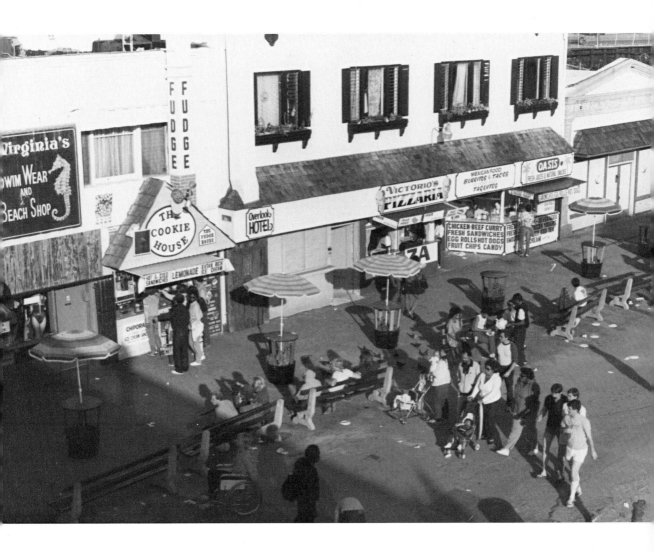

Marlowe is out strolling along Ocean Front Walk, waiting for the sun to go down, so he can take the water taxi to the *Montecito* gambling boat. He suspects that the owner, Laird Brunette, has killed more than one or two people and might also know the whereabouts of Velma, Moose Malloy's girl.

The Santa Monica Pier has been the subject of public debate in the city for decades. In the 1960s, when a majority of the City Council members decided that it should be torn down, they were swept out of office. While elected officials have since kept to themselves any thoughts of dismantling the venerable pier, a series of recent winter storms has managed to shorten its main span by several dozen feet. Even in its abridged version, the pier continues to be a favorite location for motion picture and television filming, particularly for its period flavor in such movies as *The Sting*.

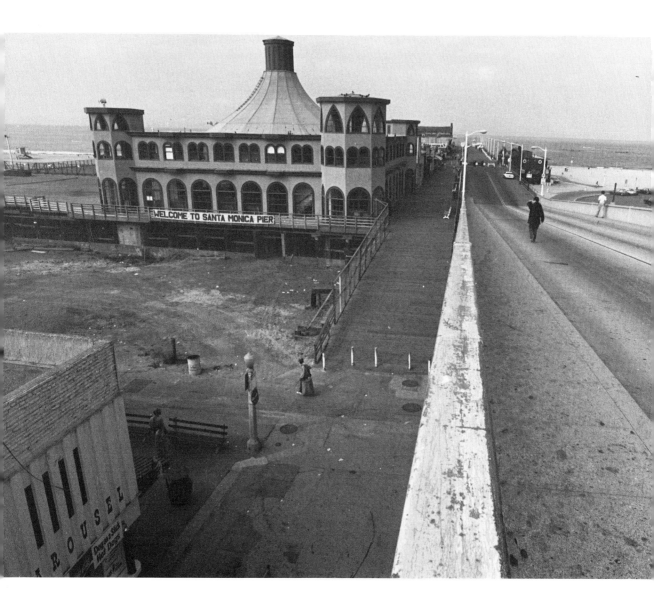

Santa Monica Beach and the Pacific Ocean.

37 / WHAT I NEEDED, WHAT I HAD

I lay on my back on a bed in a waterfront hotel and waited for it to get dark. It was a small front room with a hard bed and a mattress slightly thicker than the cotton blanket that covered it. A spring underneath me was broken and stuck into the left side of my back. I lay there and let it prod me.

The reflection of a red neon light glared on the ceiling. When it made the whole room red it would be dark enough to go out. Outside cars honked along the alley they called the Speedway. Feet slithered on the sidewalks below my window. There was a murmur and mutter of coming and going in the air. The air that seeped in through the rusted screens smelled of stale frying fat. Far off a voice of the kind that could be heard far off was shouting: "Get hungry, folks. Get hungry. Nice hot doggies here. Get hungry. . . ."

It got darker. The glare of the red neon sign spread farther and farther across the ceiling. I sat up on the bed and put my feet on the floor and rubbed the back of my neck.

I got up on my feet and went over to the bowl in the corner and threw cold water on my face. After a little while I felt better, but very little. I needed a drink, I needed a lot of life insurance, I needed a vacation, I needed a home in the country. What I had was a coat, a hat and a gun. I put them on and went out of the room.

Farewell, My Lovely

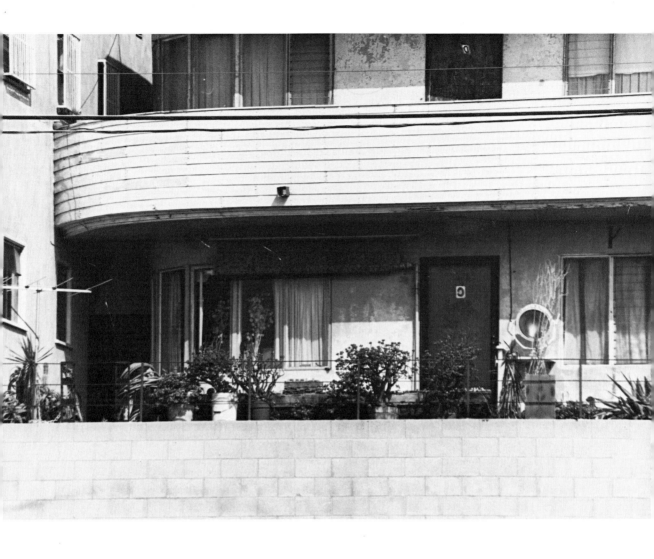

Santa Monica's beachfront merges unremarkably with Venice just south of the pier. In the twenties, the Venice canals were brand new and there were four different piers in this area, three of them with roller coasters and all with carnival entertainments, such as carousels and heated indoor plunges. Ocean Front Walk faced the sea with an array of resorts, theaters, ballrooms, and restaurants that tried to be deluxe. Most of the structures were torn down in the 1950s and 1960s, when they failed to meet newer and stricter fire codes.

Venice began life as part of tobacco-baron Abbot Kinney's vision of an American renaissance. For a while there were actually gondolas in the Venice canals, manned by native Venetians hired by Kinney. Venice has lost most of its Mediterranean flavor, as its waters stagnated and its transient population grew. In the thirties all but three of its original sixteen miles of canals were drained. Venice has enjoyed something of a revival beginning in the late sixties; and most recently, after a decade of wrangling, Los Angeles has set a timetable for cleaning up the remaining canals. In the meantime, Venice remains a locus full of exotic promise and stopped-up plumbing, where forever-young hipsters dodge the roller skaters on the concrete boardwalk.

The Kensington Hotel, Ocean Avenue, Santa Monica.

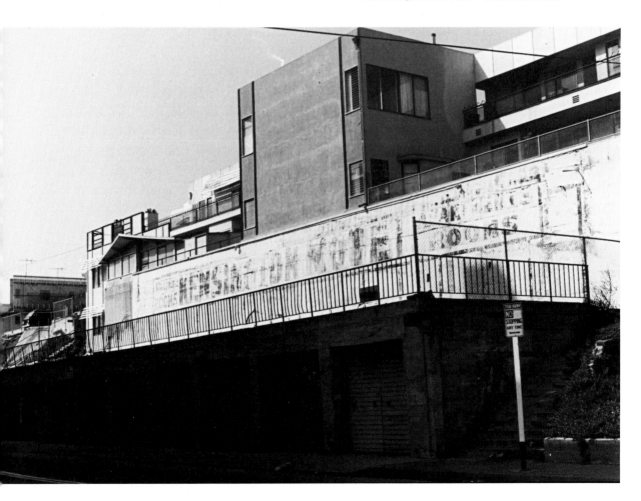

38/TWO HUNDRED AND EIGHTY STEPS

I got down to Montemar Vista as the light began to fade, but there was still a fine sparkle on the water and the surf was breaking far out in long smooth curves. A group of pelicans was flying bomber formation just under the creaming lip of the waves. A lonely yacht was tacking in toward the yacht harbor at Bay City. Beyond it the huge emptiness of the Pacific was purple-gray.

Montemar Vista was a few dozen houses of various sizes and shapes hanging by their teeth and eyebrows to a spur of mountain and looking as if a good sneeze would drop them down among the box lunches on the beach.

Above the beach the highway ran under a wide concrete arch which was in fact a pedestrian bridge. From the inner end of this a flight of concrete steps with a thick galvanized handrail on one side ran straight as a ruler up the side of the mountain. Beyond the arch, the sidewalk cafe my client had spoken of was bright and cheerful inside, but the iron-legged tile-topped tables outside under the striped awning were empty save for a single dark woman in slacks who smoked and stared moodily out to sea, with a bottle of beer in front of her. A fox terrier was using one of the iron chairs for a lamppost. She chided the dog absently as I drove past and gave the sidewalk cafe my business to the extent of using its parking space.

I walked back through the arch and started up the steps. It was a nice walk if you liked grunting. There were two hundred and eighty steps up to Cabrillo Street. They were drifted over with windblown sand and the handrail was as cold and wet as a toad's belly.

When I reached the top the sparkle had gone from the water and a seagull with a broken trailing leg was twisting against the offsea breeze. I sat down on the damp cold top step and shook the sand out of my shoes and waited for my pulse to come down into the low hundreds. When I was breathing more or less normally again I shook my shirt loose from my back and went along to the lighted house which was the only one within yelling distance of the steps. . . .

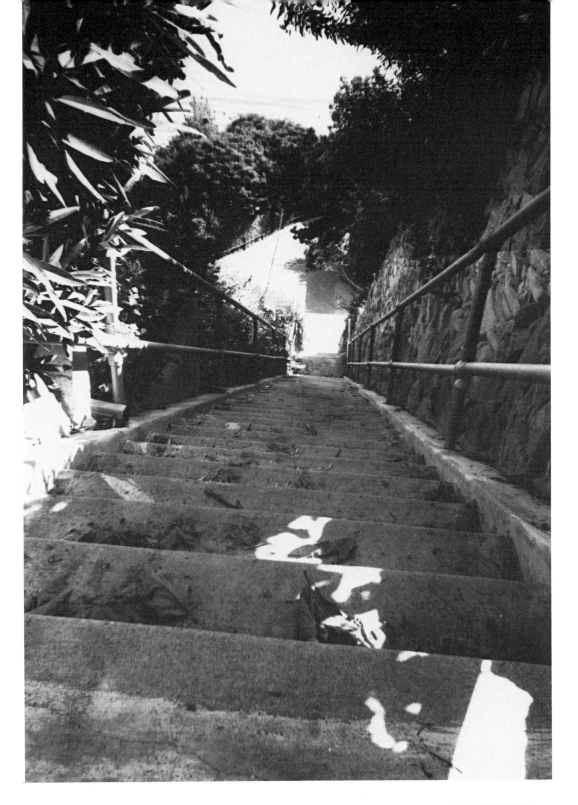

It was a nice little house . . . I went up the spiral steps, looked for a bell, and used a knocker in the shape of a tiger's head. Its clatter was swallowed in the early evening fog. I heard no steps in the house. My damp shirt felt like an icepack on my back. The door opened silently. . . .

"Seven o'clock." I said. "On the dot."

Farewell, My Lovely

preceding page and opposite:
Stairway just east of Pacific Coast Highway.

17572 Pacific Coast Highway, Castellammare.

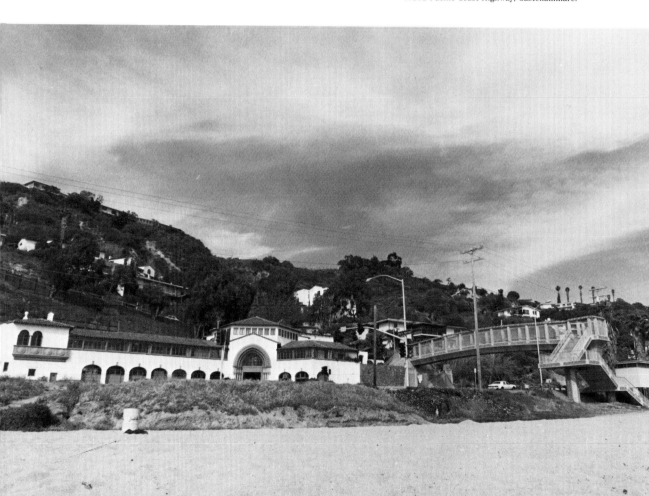

Three miles north of Santa Monica is the informal community of Castellammare, which Chandler called "Montemar Vista." (There is now an actual Monte Mar Vista, developed since Chandler's time, south of Beverly Hills.) Using several stairways and the pedestrian overpass at the coast highway, it is still possible to walk down from the foothills to the sand. Chandler's "two hundred and eighty steps" echo the "fifty-five steps" and the "ninety-nine steps," actual names of earlier walkways to the beach in Santa Monica. The Spanish-style structure with the myriad arches on the land side of the overpass did at one time house a sidewalk cafe, Thelma Todd's Roadside Rest. In the thirties it belonged to actress Thelma Todd, whose mysterious death—her body was found in her car parked inside her garage—was never solved. Today the building is the headquarters of Paulist Productions, a Catholic religious group that produces short films and television programs.

View from Coldwater Canyon Boulevard.

House on Adelaide Street, Santa Monica.

These houses may not have all the variety of "size and shape" that Marlowe saw, but they are certainly "hanging by their teeth and eyebrows."

Chandler often situated unusual people in unusual buildings and first described what he called "clinging vine effects" in "Try the Girl." He embellished the description with the house on "Altair Street" atop a coastal canyon: "His house was built downwards, one of those clinging vine effects, with the front door a little below street level, the patio on the roof, the bedroom in the basement, and a garage like a corner pocket on a pool table." (*The Lady in the Lake*).

39 / A FAMILY THINGS HAPPEN TO

*W*e drove out Sunset, using the siren once in a while to beat a signal. It was a crisp morning, with just enough snap in the air to make life seem simple and sweet, if you didn't have too much on your mind. I had.

It was thirty miles to Lido on the coast highway, the first ten of them through traffic. Ohls made the run in three quarters of an hour. At the end of that time we skidded to a stop in front of a faded stucco arch and I took my feet out of the floorboards and we got out. A long pier railed with white two-by-fours stretched seaward from the arch. . . . We went out on the pier, into a loud fish smell which one night's hard rain hadn't even dented. . . .

A low black barge with a wheelhouse like a tug's was crouched against the pilings at the end of the pier. Something that glistened in the morning sunlight was on its deck, with hoist chains still around it, a large black and chromium car. . . . The upholstery was sodden and black. None of the tires seemed to be damaged.

The driver was still draped around the steering post with his head at an unnatural angle to his shoulders.

The Big Sleep

Malibu Pier, Malibu.

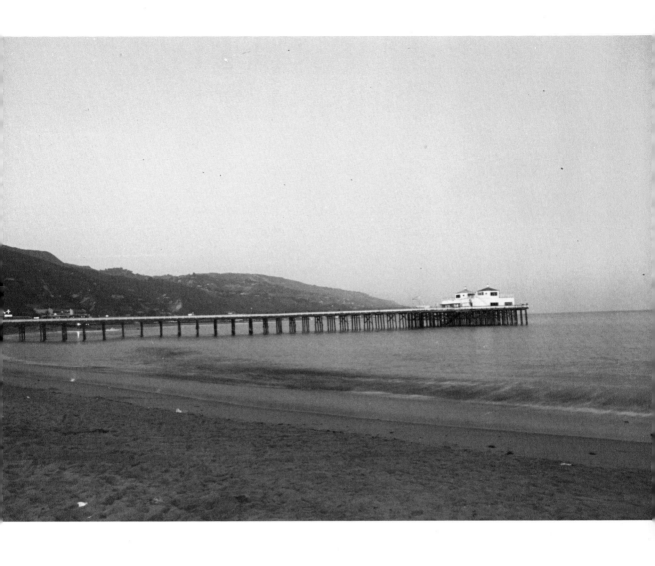

40 / IF ANYONE EVER BOTHERS YOU

"*If anybody ever bothers you,*" *I said,* "*let me know.*"

I went out of the bar without looking back at her, got into my car and drove west on Sunset and down all the way to the Coast Highway. Everywhere along the way gardens were full of withered and blackened leaves and flowers which the hot wind had burned.

But the ocean looked cool and languid and just the same as ever. I drove on almost to Malibu and then parked and went and sat on a big rock that was inside somebody's wire fence. It was about half-tide and coming in. The air smelled of kelp. I watched the water for a while and then I pulled a string of Bohemian glass imitation pearls out of my pocket and cut the knot at one end and slipped the pearls off one by one.

When I had them all loose in my left hand I held them like that for a while and thought. There wasn't really anything to think about. I was sure.

"*To the memory of Mr. Stan Phillips,*" *I said aloud.* "*Just another four-flusher.*"

I flipped her pearls out into the water one by one at the floating seagulls.

They made little splashes and the seagulls rose off the water and swooped at the splashes.

Red Wind

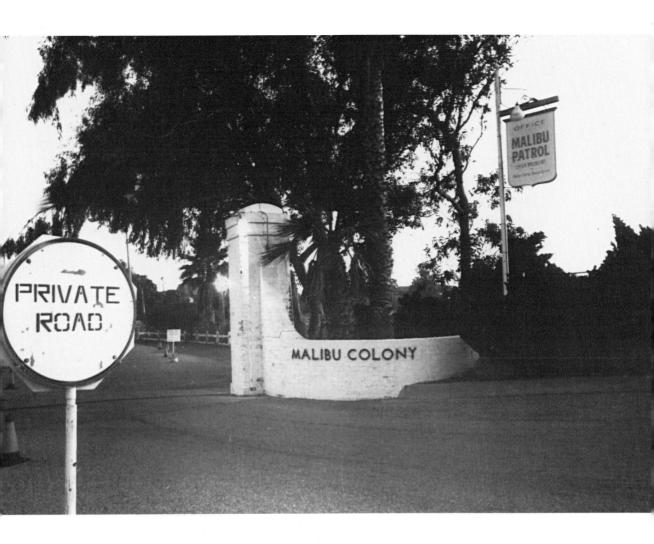

The current Malibu Pier was completed in 1946, after Marlowe and Bernie Ohls' visit. Its predecessor, which jutted out into the same stretch of ocean, dated from 1903 and was, for decades prior to the completion of the coast highway, Malibu's main link with the cities to the south.

From its founding, Malibu was a cool, rustic escape from the grimy city, a summer retreat which those of average income could not hope to enjoy. The exodus of movie stars to Malibu and the establishment of an exclusive beach colony was reputedly begun by Anna Q. Nilsson in 1926. The first colonists certainly did value their privacy. In the absence of a road up the coast from Santa Monica, travelers had to come down the trail through Malibu Canyon or take a boat to Malibu Pier. The owner of the Malibu ranchlands, Frederick Rindge, did all he could to dissuade immigration; but when the coast highway reached Malibu in 1929, the floodgates were opened. Malibu Colony itself, which is just a private drive along a prime stretch of beach, was formally established in the 1930s.

In today's Malibu, beach homes stretch side by side for miles, forming a barrier between highway and ocean that is infrequently broken by a narrow public accessway. The Malibu which Marlowe visits in the "Red Wind" and *The Big Sleep* was much closer to Rindge's ideal, still isolated enough for man to sit on a rock pitching pearls into the waves without attracting any attention.

Stairway labeled "Castellammare" leading up from the coast highway.

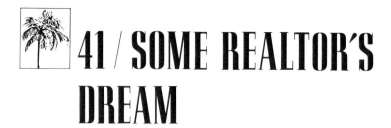

41 / SOME REALTOR'S DREAM

*O*n the highway the lights of the streaming cars made an almost solid beam in both directions. The big cornpoppers were rolling north growling as they went and festooned all over with green and yellow overhang lights. Three minutes of that and we turned inland, by a big service station, and wound along the flank of the foothills. It got quiet. There was loneliness and the smell of kelp and the smell of wild sage from the hills. A yellow window hung here and there, all by itself, like the last orange. Cars passed, spraying the pavement with cold white light, then growled off into the darkness again. Wisps of fog chased the stars down the sky. . . .

I swung the car to the right. . . . We slid down a broad avenue lined with unfinished electroliers and weed-grown sidewalks. Some realtor's dream had turned into a hangover there. . . .

Then the paved avenue ended abruptly in a dirt road packed as hard as concrete in dry weather. The lights of the Belvedere Beach Club hung in the air to the right and far ahead there was a gleam of moving water. The acrid smell of sage filled the night. Then a white painted barrier loomed across the dirt road. . . .

I cut the noiseless motor, dimmed the lights and sat there, listening. Nothing. I switched the lights off altogether and got out of the car. The crickets stopped chirping. For a little while the silence was so complete that I could hear the sound of tires on the highway at the bottom of the cliffs, a mile away. . . .

Minute passed slowly after minute, but I kept on waiting for some new sound. None came. I seemed to have that hollow entirely to myself. . . .

Still nothing. The black car stood dimly shining against a grayness which was neither darkness nor light.

"Looks like a tryout," I said under my breath, but loud enough for Marriott to hear me from the back of the car. "Just to see if you obey orders."

There was a vague movement behind but he didn't answer. I went on trying to see something besides bushes.

Whoever it was had a nice easy shot at the back of my head. Afterwards I thought I might have heard the swish of a sap. Maybe you always think that—afterwards.

Farewell, My Lovely

preceding page:
Santa Ynez Canyon, between Castellammare and Pacific Palisades Highlands.

Chandler sends Marlowe on a dangerous ride up the coast to "Purissima Canyon." There are several canyons branching up into the Santa Monica Mountains from the Pacific that could still be considered a realtor's dream. Temescal, Topanga, Tuna, or Big Rock Canyons all fit Marlowe's time frame of being "three minutes" more or less from Castellammare. Santa Ynez is to the west, accessible from Sunset Boulevard.

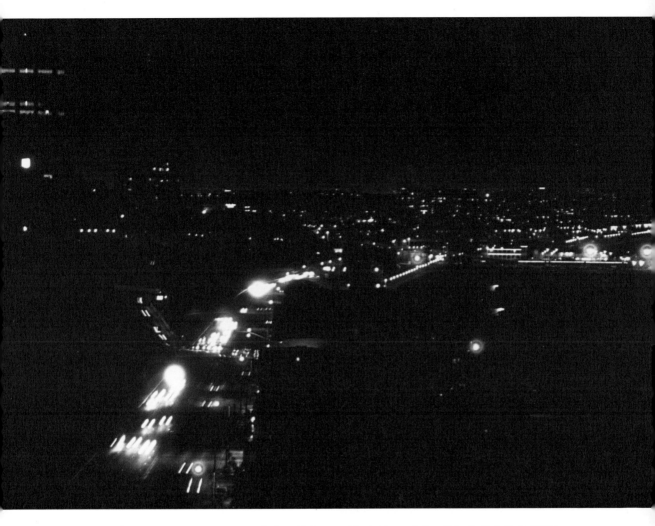

Pacific Coast Highway at night, looking south from Palisades Park, Santa Monica.

 # 42 / FOUR SQUARE MILES

*T*hen, before we got to where Santa Monica turns into Arguello Boulevard, Lin said, "Let's go over the other road," and turned up some curving residential street. Then all of a sudden a car rushed by us and grazed the fender and then pulled to a stop. A man in an overcoat and scarf and hat low on his face came back to apologize He jerked the scarf up over his nose and a gun was shining at us. "Stick-up," he said. "Be very quiet and everything will be jake. . . ."

"In Beverly Hills," I said, "the best policed four square miles in California."

Farewell, My Lovely

Beverly Hills City Hall, Santa Monica Boulevard and Crescent Drive, Beverly Hills.

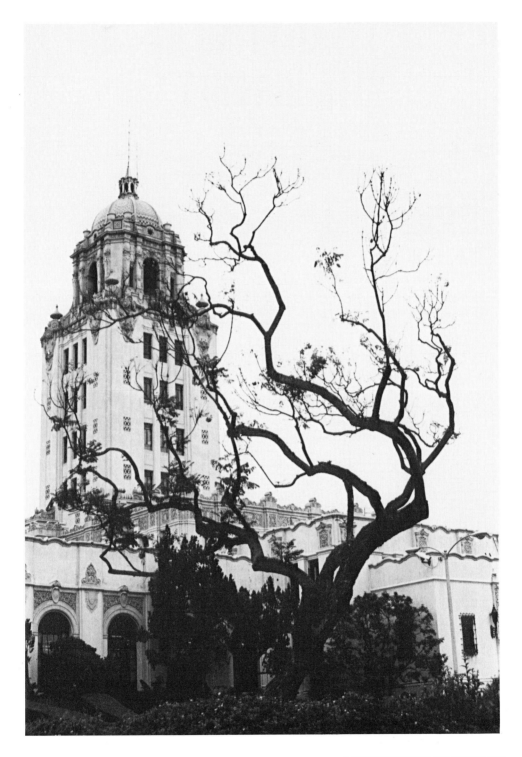

43 / MEETING AT THE RITZ-BEVERLY

*A*t *eleven o'clock I was sitting in the third booth on the right-hand side as you go in from the dining-room annex. I had my back against the wall and I could see anyone who came in or went out. . . .*

The bar was pretty empty. Three booths down a couple of sharpies were selling each other pieces of Twentieth Century-Fox, using double-arm gestures instead of money. They had a telephone on the table between them and every two or three minutes they would play the match game to see who called Zanuck with a hot idea. They were young, dark, eager and full of vitality. They put as much muscular activity into a telephone conversation as I would put into carrying a fat man up four flights of stairs.

There was a sad fellow over on a bar stool talking to the bartender, who was polishing a glass and listening with that plastic smile people wear when they are trying not to scream.

The Long Goodbye

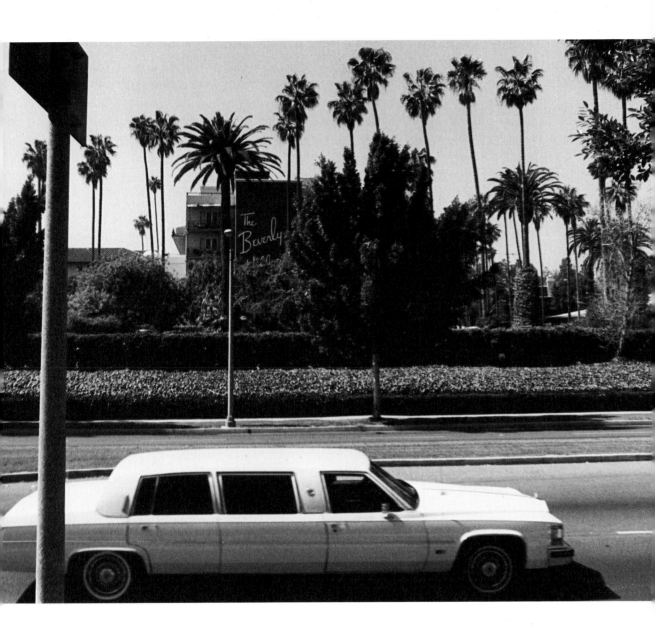

In the 19th Century, Rancho Rodeo de las Aguas was less concerned with the quality of its police than of its lima beans. After several earlier failures, Burton Green and his Rodeo Land and Water Company finally carved out an enclave for the very rich between Los Angeles and the Pacific.

Mrs. Grayle tells Marlowe about turning north through a residential section towards Sunset before reaching Santa Monica and Arguello (Wilshire). Marlowe's response is anything but facetious. The Beverly Hills of Chandler's time was already renowned for its polite but firm xenophobia. Forty years later, the concept of "the best policed four square miles in California" was still strong enough to form the underlying irony in the film, BEVERLY HILLS COP.

Nine blocks east of Wilshire intersection, the City Hall and the Beverly Hills Police Station behind it front the residential section north of Santa Monica. Unlike Los Angeles, the city fathers of Beverly Hills felt no inclination to mix sand from other parts of California into the mortar for their City Hall. Its Spanish Renaissance design by William Gage is meant to embody dual traditions of culture and wealth.

When Marlowe first visited what Chandler called the Ritz-Beverly, it had more of its original Mission style and was at 1201 Sunset Boulevard, a Beverly Hills street number. The hotel's address is now contiguous with the Los Angeles numbers both east and west, but the clientele is unchanged. From its opening in 1912, the Beverly Hills Hotel sought to epitomize luxury service with a price to match. If Axel Foley from BEVERLY HILLS COP had known the city better, he would likely have stayed here and not the Beverly Wilshire. Of course, even the resourceful Mr. Foley would have been hard pressed to visit the celebrated Polo Lounge, which still has a dress code. But Marlowe knew how to dress. For him, the Ritz-Beverly bar was a great place to watch supercilious people agonize over their inconsequential problems.

44/ CALLING ON FOUR MILLION DOLLARS

*I*t *was about eleven o'clock in the morning, mid October, with the sun not shining and a look of hard wet rain in the clearness of the foothills. I was wearing my powder-blue suit, with dark blue shirt, tie and display handkerchief, black brogues, black wool socks with dark blue clocks on them. I was neat, clean, shaved and sober, and I didn't care who knew it. I was everything the well-dressed private detective ought to be. I was calling on four million dollars. . . .*

There were French doors at the back of the hall, beyond them a wide sweep of emerald grass. . . . Beyond them a large greenhouse with a domed roof. . . .

I stood on the step breathing my cigarette smoke and looking down a succession of terraces with flowerbeds and trimmed trees to the high iron fence with gilt spears that hemmed in the estate. A winding driveway dropped down between retaining walls to the open iron gates. Beyond the fence the hill sloped for several miles. On this lower level faint and far off I could just barely see some of the old wooden derricks of the oilfield from which the Sternwoods had made their money A little of it was still producing in groups of wells pumping five or six barrels a day. The Sternwoods, having moved up the hill, could no longer smell the stale sump water or the oil, but they could still look out of their front windows and see what had made them rich. If they wanted to. I didn't suppose they would want to.

The Big Sleep

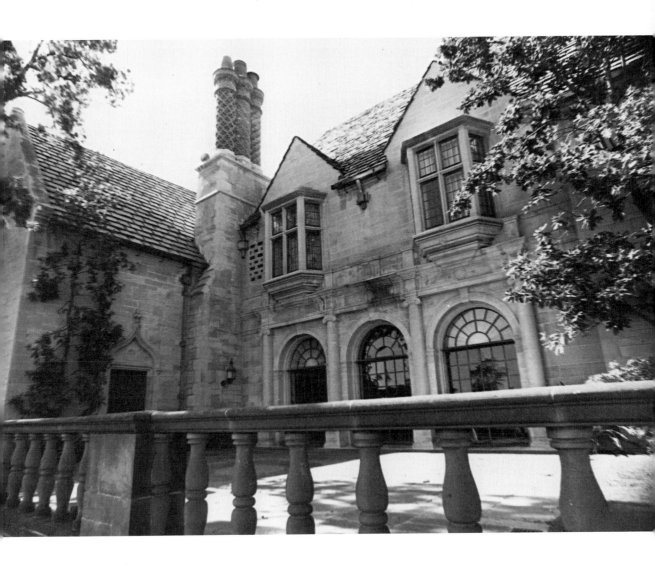

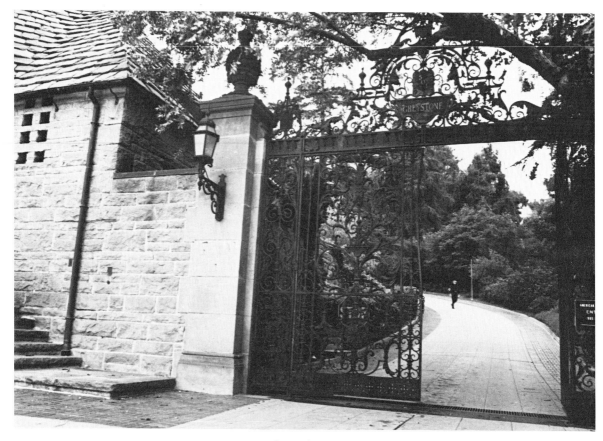

above and opposite:
Doheny Mansion (Greystone), 501 North Doheny Road, Beverly Hills.

Chandler's General Sternwood is an oilman who built his mansion above the stench of his wells and his business methods. E. L. Doheny's wells were so successful that, even after buying up Chester Place (see Excerpt 1), he had ample capital left to erect this fifty-five-room Tudor and Jacobean manor on an eighteen acre estate for his son and heir. Construction began in 1925, took more than two years, and cost, as it happens, four million dollars. As a Dabney-Johnson executive Chandler might have attended an industry party at Greystone and crossed the tesselated marble floors to sip cocktails on the terrace.

From Greystone, the Dohenys could look toward their oil fields in the Baldwin Hills and, like Marlowe, could see the silhouettes of derricks outlined against the sky.

Since 1964, Greystone has belonged to the city of Beverly Hills. It has frequently been rented as a movie location. It doubled for an exclusive memorial park in *The Loved One* and a sanitarium in *The Disorderly Orderly*. In the 1970s, the estate was leased to the American Film Institute, which did extensive renovation in creating its first Center for Advanced Film Study. The AFI has moved to the Los Feliz area, and the mansion itself is now closed to the public; but the upper grounds of fountains, terraced rose gardens, and reflecting pools are now a public park with an entrance at 905 Loma Vista Drive.

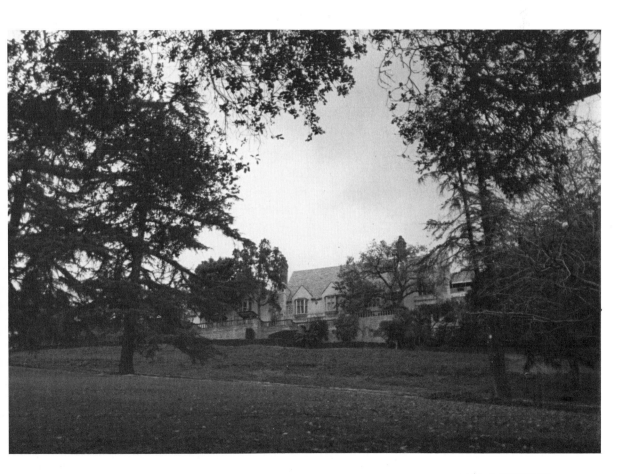

45 / DO YOU LIKE ORCHIDS?

*W*e went out at the French doors and along a smooth red-flagged path that skirted the far side of the lawn from the garage The path took us along to the side of the greenhouse and the butler opened a door for me and stood aside Then it was really hot. The air was thick, wet, steamy and larded with the cloying smell of tropical orchids in bloom. The glass walls and roof were heavily misted and big drops of moisture splashed down on the plants. The light had an unreal greenish color, like light filtered through an aquarium tank. The plants filled the place, a forest of them, with nasty meaty leaves and stalks like the newly washed fingers of dead men. They smelled as overpowering as boiling alcohol under a blanket. . . .

After a while we came to a clearing in the middle of the jungle, under the domed roof. Here, in a space of hexagonal flags, an old red Turkish rug was laid down and on the rug was a wheel chair, and in the wheel chair an old and obviously dying man watched us come with black eyes from which all fire had died long ago. . . .

"A nice state of affairs when a man has to indulge his vices by proxy," he said dryly. "You are looking at a very dull survival of a rather gaudy life. . . . I seem to exist largely on heat, like a newborn spider, and the orchids are an excuse for the heat. Do you like orchids?"

The Big Sleep

Greenhouse, Doheny Mansion, Beverly Hills.

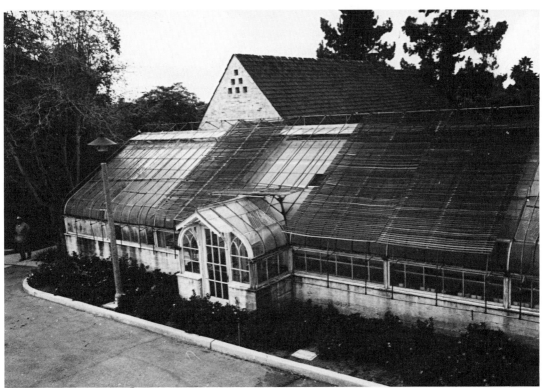

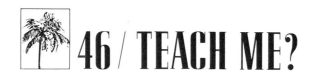

46 / TEACH ME?

"*Teach me how to shoot. I'd like that.*"

"*Here? It's against the law.*"

She came close to me and took the gun out of my hand, cuddled her hand around the butt. Then she tucked it quickly inside her slacks, almost with a furtive movement, and looked around.

"*I know where,*" *she said in a secret voice.* "*Down by some of the old wells.*" *She pointed off down the hill.* "*Teach me?*". . . .

I drove on down the hill through the quiet opulent streets with their faces washed by the rain, bore east to La Brea, then south. We reached the place she meant in about ten minutes.

"*In there.*" *She leaned out of the window and pointed.*

It was a narrow dirt road, not much more than a track, like the entrance to some foothill ranch. A wide five-barred gate was folded back against a stump and looked as if it hadn't been shut in years. The road was fringed with tall eucalyptus trees and deeply rutted. Trucks had used it. It was empty and sunny now, but not yet dusty. The rain had been too hard and too recent. I followed the ruts along and the noise of the city traffic grew curiously and quickly faint, as if this were not in the city at all, but far away in a daydream land. Then the oil-stained motionless walking-beam of a squat wooden derrick stuck up over a branch. I could see the rusty old steel cable that connected this walking-beam with a half dozen others. The beams didn't move, probably hadn't moved for a year. The wells were no longer pumping. There was a pile of rusted pipe, a loading platform that sagged at one end, half a dozen empty oil drums lying in a ragged pile. There was the stagnant, oil-scummed water of an old sump iridescent in the sunlight.

"*Are they going to make a park out of all this?*" *I asked.* . . .

"*Uh-huh. Like it?*"

"*It's beautiful*". . . . *Even after the rain the eucalyptus trees still looked dusty. They always look dusty. A branch broken off by the wind had fallen over the edge of the sump and the flat leathery leaves dangled in the water.* . . .

What did it matter where you lay once you were dead? In a dirty sump or in a marble tower on top of a high hill? You were dead, you were sleeping the big sleep, you were not bothered by things like that. Oil and water were the same as wind and air to you. You just slept the big sleep, not caring about the nastiness of how you died or where you fell. Me, I was part of the nastiness now. Far more a part of it than Rusty Regan was. But the old man didn't have to be. He could lie quiet in his canopied bed, with his bloodless hands folded on the sheet, waiting. His heart was a brief, uncertain murmur. His thoughts were as gray as ashes. And in a little while he too, like Rusty Regan, would be sleeping the big sleep.

The Big Sleep

preceding page:
Baldwin Hills oil field just south of Jefferson Boulevard, Culver City.

After Doheny sunk his first successful well, hundreds of wells followed. In the Baldwin Hills scores are still pumping.

View over the main house, looking south.

47 / LAVERNE TERRACE

*H*alfway up the grade he turned left and took a curving ribbon of wet concrete which was called Laverne Terrace. It was a narrow street with a high bank on one side and a scattering of cabin-like houses built down the slope on the other side, so that their roofs were not very much above road level. Their front windows were masked by hedges and shrubs. Sodden trees dripped all over the landscape.

The Big Sleep

House in Hollywood Hills, west of Laurel Canyon.

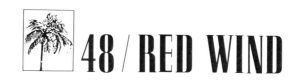

48 / RED WIND

*T*here was a desert wind blowing that night. It was one of those hot dry Santa Anas that come down through the mountain passes and curl your hair and make your nerves jump and your skin itch. On nights like that every booze party ends in a fight. Meek little wives feel the edge of the carving knife and study their husbands' necks. Anything can happen. You can even get a full glass of beer at a cocktail lounge. . . .

"There's a hell of a lot of coincidence in all this business," the big man said.
"It's the hot wind," I grinned. "Everybody's screwy tonight.". . .

"I like it better that you don't live long enough to laugh about that baby."
My mouth felt suddenly hot and dry. Far off I heard the wind booming. It seemed like the sound of guns.

Red Wind

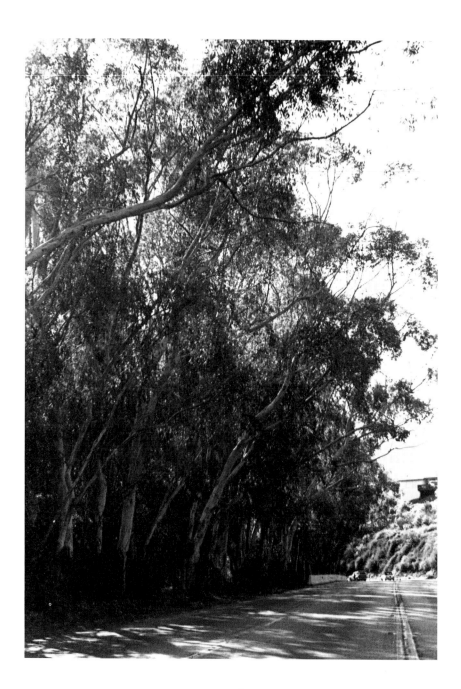

Stand of eucalyptus along Sunset Boulevard, just east of Chautauqua.

There are numerous terraces off Laurel Canyon; and as Marlowe observed, a few of the cabinlike houses are built downslope, so that their roofs are at road level. Just around the bend from this location is Yucca Avenue, where Marlowe lived in a hillside house in *The Long Goodbye*.

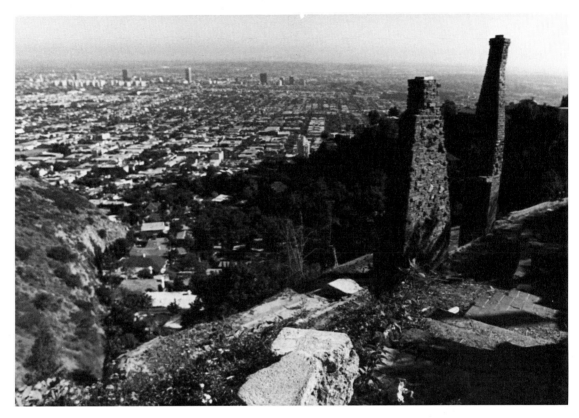

Burned out house just above Yucca Avenue.

Chandler's description of the "red wind," the hot, dry Santana condition that plagues Los Angeles in late fall and early winter, may be his best prose. It is certainly the most often quoted passage from any of his work. When the red wind blows its highly ionized breath over the Hollywood Canyons, the already dry vegetation shrivels and a single spark can ignite a mountainside. When he lived on Yucca, Marlowe had eucalyptus such as these in his back yard, and from his kitchen window he likely could watch the grass yellowing around them.

Marlowe's hillside house in *The Long Goodbye* is literally just around the bend from Geiger's place in *The Big Sleep* (Excerpt 47). There are numerous terraces off Laurel Canyon; and as Marlowe observed, a few of the cabin-like homes are built downslope, so that their roofs are at road level.

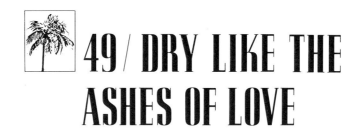

49 / DRY LIKE THE ASHES OF LOVE

*S*he said something in a spitting language. Then in English: "Come in! Thees damn wind dry up my skeen like so much teesue paper . . .".

"Goddam, thees hot wind make me dry like the ashes of love," the Russian girl said bitterly.

Red Wind

Woman in swimming pool, La Mirada.

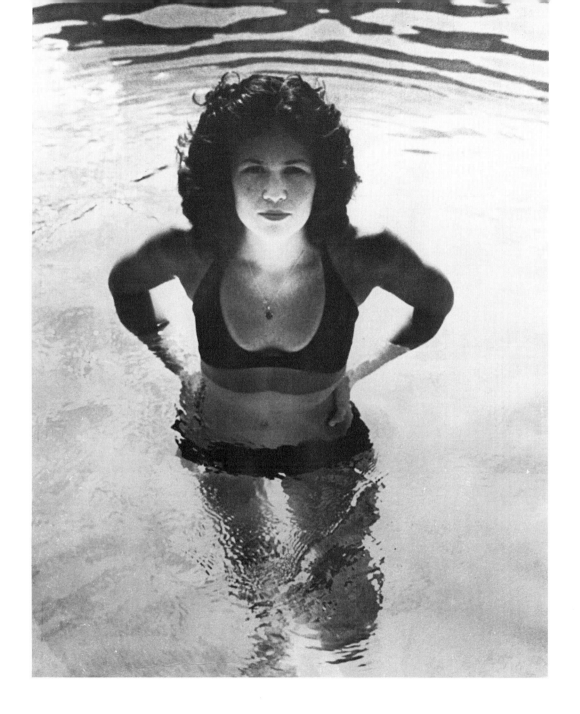

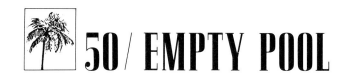

50 / EMPTY POOL

*O*ff to my left there was an empty swimming pool, and nothing ever looks emptier than an empty swimming pool. Around three sides of it there was what remained of a lawn dotted with redwood lounging chairs with badly faded pads on them. The pads had been of many colors, blue, green, yellow, orange, rust-red. Their edge bindings had come loose in spots, the buttons had popped, and the pads were bloated where this had happened. The diving board over the empty pool looked knee-sprung and tired. Its matting covering hung in shreds and its metal fittings were flaked with rust.

The Long Goodbye

Empty pool, Chester Place.

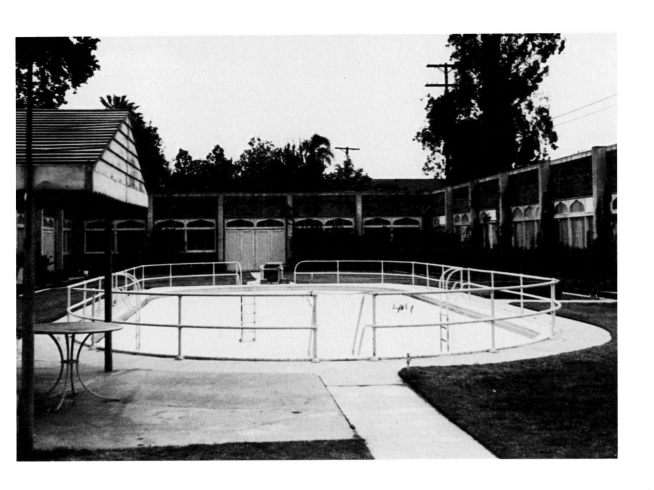

51 / CRAWLING LAVA

*T*he wind had risen and had a dry taut feeling, tossing the tops of trees, and making the swung arc light up the side street cast shadows like crawling lava. I turned the car and drove east again.

The High Window

Eucalyptus leaves and street lamp, Palisades Park, Santa Monica.

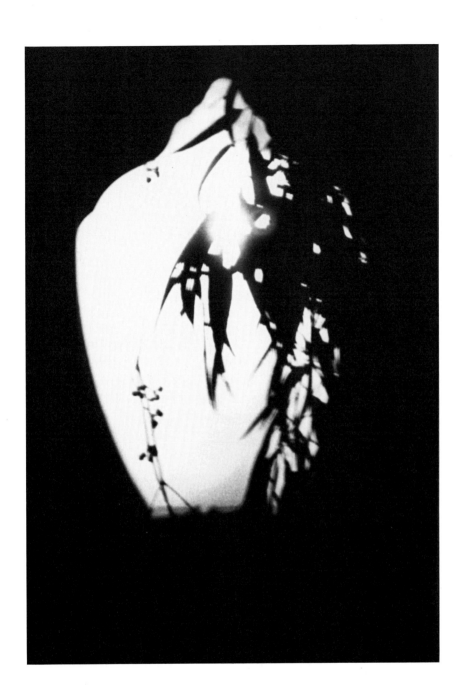

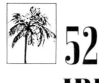

52 / I BELONGED IN
IDLE VALLEY

I knew a good deal about Idle Valley, and I knew it had changed a great deal from the days when they had the gatehouse at the entrance and the private police force, and the gambling casino on the lake, and the fifty-dollar joy girls. Quiet money had taken over the tract after the casino was closed out. Quiet money had made it a subdivider's dream. A club owned the lake and the lake frontage and if they didn't want you in the club, you didn't get to play in the water. It was exclusive in the only remaining sense of the word that doesn't mean merely expensive.

I belonged in Idle Valley like a pearl onion on a banana split.

The Long Goodbye

View of Malibu Lake, looking south from Mulholland Highway.

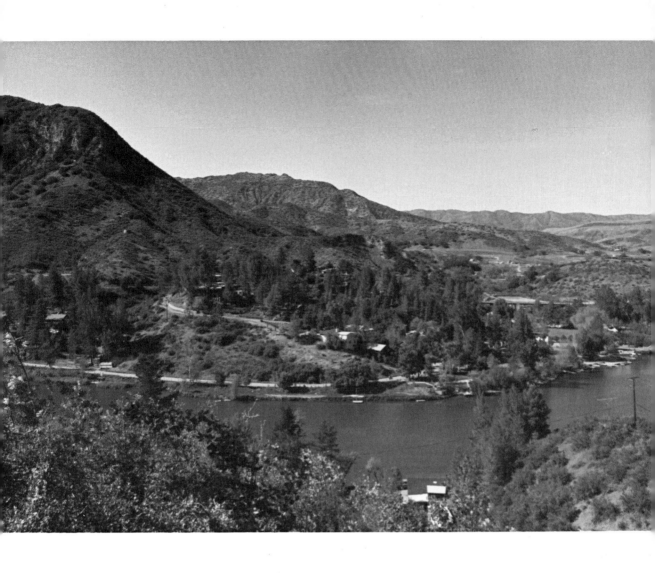

53 / BREATHLESS AIR

*T*he house was on Dresden Avenue in the Oak Knoll section of Pasadena, a big solid cool-looking house with burgundy brick walls, a terra cotta tile roof, and a white stone trim. . . .

There was a heavy scent of summer on the morning and everything that grew was perfectly still in the breathless air they get over there on what they call a nice cool day.

The High Window

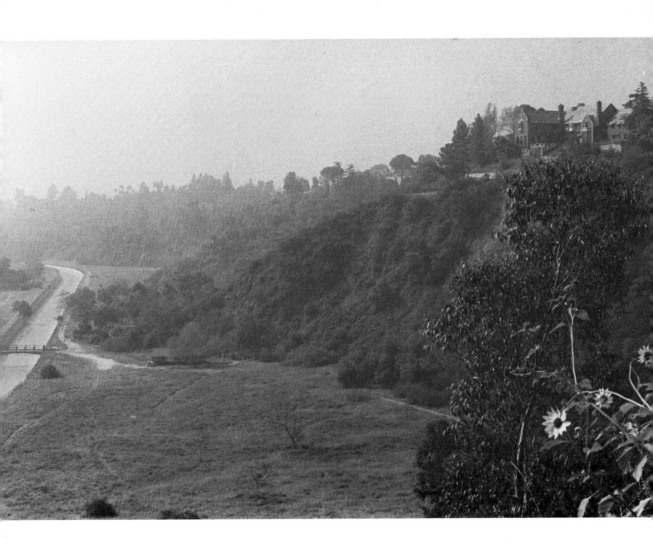

The suburbs of Los Angeles are full of pools. Few if any bother to drain them during the winter; and if a hot day comes along, why not use it. As for women in pools, in *The Long Goodbye*, Marlowe enjoys watching one until "she wobbled her bottom over to a small table and sat down She opened a mouth like a firebucket and laughed. That terminated my interest in her."

There are, of course, abandoned pools with neither women nor water in them. Chandler is quick to seize the obvious metaphor in its emptiness and then subtly elaborate with a detailed list of the now useless appurtenances. This pool was part of the Doheny complex at Chester Place.

When Chandler wrote about Southern California, private pools still epitomized wealth. For Marlowe the most nettlesome thing about his occasionally rich clients was having to go visit them in their private playgrounds. What could be a more appropriate display of wealth for a private community such as Idle Valley than a private lake? For a while, Chandler considered calling *The Long Goodbye*, *Summer in Idle Valley*. There are several private communities at the western edge of Los Angeles County. Some, such as Hidden Hills, still retain the gatehouse and the private guards that "Idle Valley" once had. Malibu Lake, the community and the body of water, were created in 1926 by the Malibu Lake Mountain Club. The main drive, Lake Vista, is now a public road; but the lake itself, the clubhouse on the west bank, and many of the side roads remain private.

Closer view of house, taken from Colorado Street Bridge.

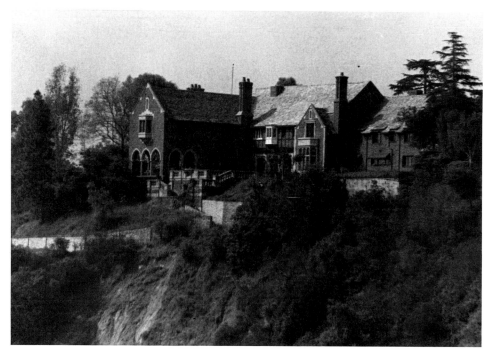

Now as in Chandler's time, Pasadena means old houses and old money. On the ridges along Arroyo Seco, the dry creek that runs south from the Rose Bowl on Pasadena's western edge, are experiments by Frank Lloyd Wright and the homes that made Charles and Henry Greene Los Angeles' most famous architects. The Oak Knoll section which Chandler mentions abutts even wealthier and more exclusive San Marino; but Pasadena's original "Millionaire's Row" was Orange Grove Boulevard just south of the arroyo. The most impressive of the huge estates there was Wrigley House, now the headquarters of the Tournament of Roses Association.

Unfortunately, the breathlessness of the air in Pasadena is real; and the "heavy scent" is actually ozone from the worst smog in the area.

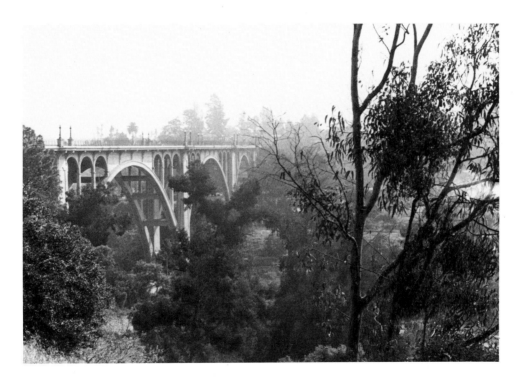

Colorado Street Bridge, Pasadena.

The bridge which spans the Arroyo Seco linking east and west Colorado Boulevards was built in 1912 and quickly became known as "Suicide Bridge." In 1937 the toll of persons who died jumping off the bridge onto the street below was joined by Lou Lid, the villain in Chandler's short story "Mandarin's Jade:" " 'Well, we got Lou Lid,' he said. 'Pasadena got Lou Lid and a Mex named Fuente. Picked them up on Arroyo Seco Boulevard. Not exactly with shovels—but kind of careful.' "

54 / LA CRESCENTA FOOD AREA

*N*icky *started the car, turned it in the middle of the block and drove north to Franklin, back over Los Feliz towards Glendale. After a little while, Zaparty leaned forward and banged on the glass. De Ruse put his ear to the hole in the glass behind Nicky's head.*

Zaparty's harsh voice said: "Stone house—Castle Road—in the La Crescenta flood area. . . ."

The big car slid noiselessly through Glendale and up the grade towards Montrose. From Montrose over to the Sunland highway and across that into the almost deserted flood area of La Crescenta.

They found Castle Road and followed it towards the mountains.· In a few minutes they came to the stone house.

It stood back from the road, across a wide space which might once have been lawn but which was now packed sand, small stones and a few large boulders. The road made a square turn just before they came to it. Beyond it the road ended in a clean edge of concrete chewed off by the flood of New Year's Day, 1934.

Beyond this edge was the main wash of the flood. Bushes grew in it and there were many huge stones. On the very edge a tree grew with half its roots in the air eight feet above the bed of the wash.

Nevada Gas

Washed out road along Big Tujunga Boulevard, Sunland.

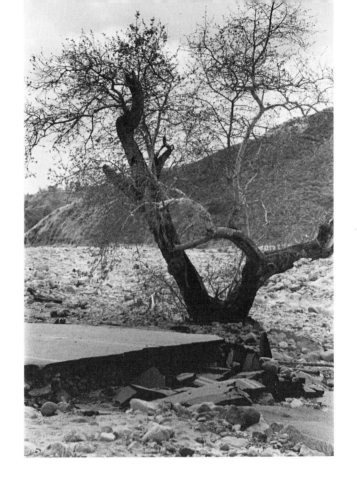

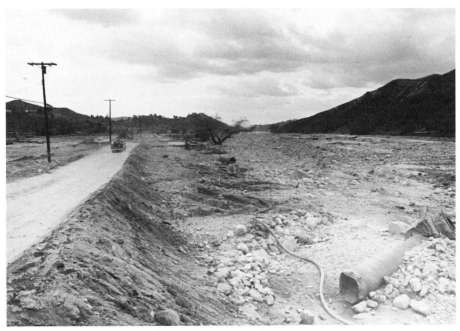

55 / THE SPOKES OF A WHEEL

*W*e ate some breakfast at Alhambra and I had the tank filled. We drove out Highway 70 and started moving past the trucks into the rolling ranch country. I was driving. Degarmo sat moodily in the corner, his hands deep in his pockets.

I watched the fat straight rows of orange trees spin by like the spokes of a wheel. I listened to the whine of the tires on the pavement and I felt tired and stale from lack of sleep and too much emotion.

We reached the long slope south of San Dimas that goes up to a ridge and drops down into Pomona. This is the ultimate end of the fog belt, and the beginning of that semi-desert region where the sun is as light and dry as old sherry in the morning, as hot as a blast furnace at noon, and drops like an angry brick at nightfall.

The Lady in the Lake

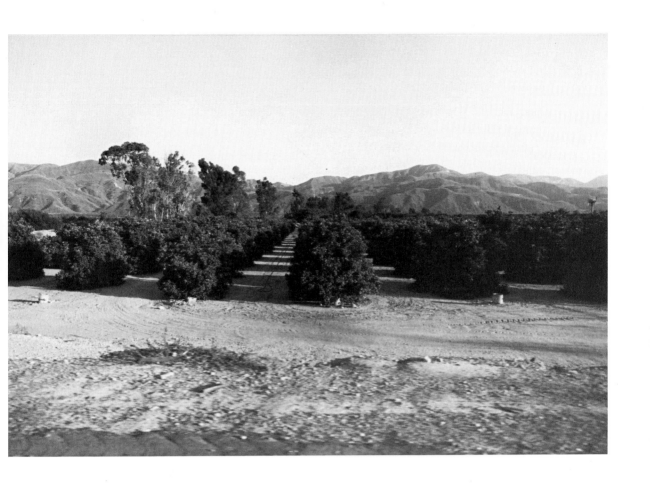

Although there is heavy competition from Florida, for many Californians, oranges have always epitomized their state. The sun-shaped, sun-colored fruit is still available year-round in California (mostly imported from Mexico), but most of the groves that Chandler would have seen in his trips around the Southland have given way to tract homes and shopping malls. It is too bad Chandler did not live to comment on those, who in response to New York's "Big Apple," have tried to give Los Angeles the appellation "Big Orange."

San Bernardino Freeway (Interstate-10) between San Dimas and Pomona.

Marlowe made this same drive along the foothills across the San Gabriel Valley after dark (and saw "endless spokes in the night") on his way to "Realito" in *The Big Sleep*. If the Chandlers took this route on their way to the San Bernardino Mountain lakes, it was when San Dimas was mainly a rail stop, halfway from downtown L.A. to the city of San Bernardino. Pomona was farmland covered with orange groves and vineyards. Now both are just part of the suburban expanse of the San Gabriel Valley in the heart of the smog belt. Further down the line, where Chandler turns north in *Farewell, My Lovely*, is San Bernardino itself, laid out by Mormon emigrants in 1851, who abandoned its inhospitable climate less than a decade later.

Of course, the most melodramatic weather possible in a climate that has neither hurricanes, tornadoes, nor blizzards, is torrential rain and flash flooding. The La Crescenta flood that Chandler described spanned 1933 and 1934, beginning on New Year's Eve and cresting the following day, all as a result of heavy rains and mountain run-off. Forty-five people died, as entire houses were swallowed up. La Crescenta has had fifty years to cover the traces of a flood that Chandler wrote about in 1935; but less than three miles up Foothill Boulevard, in Tujunga, the violence of a more recent flood is still much in evidence.

56 / CAMP KILKARE

*S*an Bernardino baked and shimmered in the afternoon heat. The air was hot enough to blister my tongue. I drove through it gasping, stopped long enough to buy a pint of liquor in case I fainted before I got to the mountains, and started up the long grade to Crestline. In fifteen miles the road climbed five thousand feet, but even then it was far from cool. Thirty miles of mountain driving brought me to tall pines and a place called Bubbling Springs. It had a clapboard store and a gas pump, but it felt like paradise. From there on it was cool all the way.

The Puma Lake dam had an armed sentry at each end and one in the middle. The first one I came to had me close all the windows of the car before crossing the dam. About a hundred yards away from the dam a rope with cork floats barred the pleasure boats from coming any closer. Beyond these details the war did not seem to have done anything much to Puma Lake.

Canoes paddled about on the blue water and rowboats with outboard motors put-putted and speedboats showing off like fresh kids made wide swathes of foam and turned on a dime and girls in them shrieked and dragged their hands in the water. Jounced around in the wake of the speedboats people who had paid two dollars for a fishing license were trying to get a dime of it back in tired-tasting fish.

The road skimmed along a high granite outcrop and dropped to meadows of coarse grass in which grew what was left of the wild irises and white and purple lupine and bugle flowers and columbine and penny-royal and desert paint brush. Tall yellow pines probed at the clear blue sky. The road dropped again to lake level and the landscape began to be full of girls in gaudy slacks and snoods and peasant handkerchiefs and rat rolls and fat-soled sandals and fat white thighs. People on bicycles wobbled cautiously over the highway and now and then an anxious-looking bird thumped past on a power-scooter.

A mile from the village the highway was joined by another lesser road A rough wooden sign under the highway said: Little Fawn Lake 1¾ miles. I took it.

Suddenly below me was a small oval lake deep in trees and rocks and wild grass, like a drop of dew caught in a curled leaf. At the near end of it was a rough concrete dam with a rope hand-rail across the top and an old millwheel at the side. Near that stood a small cabin of native pine with the bark on it.

At the far end of the lake from the dam was what looked like a small pier and a band pavilion. A warped wooden sign on it was painted in large white letters: Camp Kilkare. *I couldn't see any sense in that in these surroundings, so I got out of the car and started down towards the nearest cabin.*

The Lady in the Lake

preceding page:
Northwestern backwash, Lake Arrowhead.

Lakes Arrowhead and Big Bear are the basis of Chandler's "Puma" and "Little Fawn" lakes. Lake Arrowhead was, in fact, originally called Little Bear Lake; and Fawnskin is the name of a village along Big Bear's shore.

From the mid-thirties, Chandler and Cissy were frequent visitors to both these lakes, although the inexpensive cabins that Chandler could rent for a few weeks were more abundant around Fawnskin and Big Bear villages. By 1940, when he and Cissy could afford better accommodations, they had tired of both lakes and visited them much less frequently.

57 / PUMA LAKE DAM

*P*atton had just finished putting his calls through to block the highways when a call came through from the sergeant in charge of the guard detail at Puma Lake dam. We went out and got into Patton's car and Andy drove very fast along the lake road through the village and along the lake shore back to the big dam at the end. We were waved across the dam where the sergeant was waiting in a jeep beside the headquarters hut.

The sergeant waved his arm and started the jeep and we followed him a couple of hundred feet along the highway to where a few soldiers stood on the edge of the canyon looking down. Several cars had stopped there and a cluster of people was grouped near the soldiers. The sergeant got out of the jeep and Patton and Andy and I climbed out of the official car and went over by the sergeant.

"Guy didn't stop for the sentry," the sergeant said, and there was bitterness in his voice. "Damn near knocked him off the road. The sentry in the middle of the bridge had to jump fast to get missed. The one at this end had enough. He called the guy to a halt. Guy kept going."

The sergeant chewed his gum and looked down into the canyon.

"Orders are to shoot in a case like that," he said. "The sentry shot." He pointed down to the grooves in the shoulder at the edge of the drop. "This is where he went off."

A hundred feet down in the canyon a small coupe was smashed against the side of a huge granite boulder. It was almost upside down, leaning a little. There were three men down there. They had moved the car enough to lift something out.

Something that had been a man.

The Lady in the Lake

Big Bear Dam from the flood channel below.

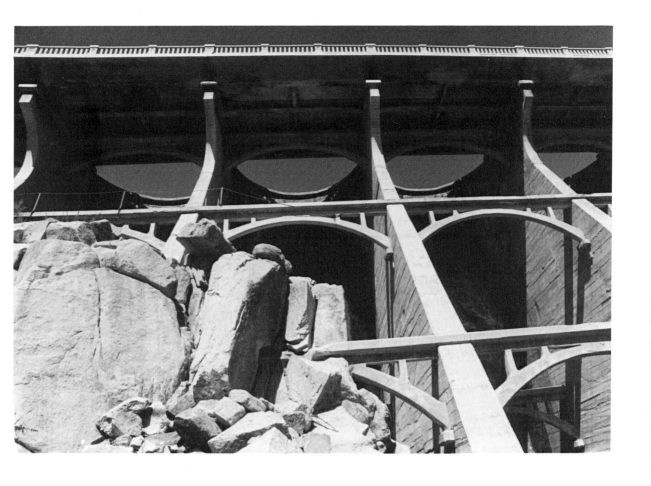

58 / LIKE A FLY IN AMBER

I *drove on through the piled masses of granite and down through the meadows of coarse grass. The same gaudy slacks and short shorts and peasant handkerchiefs as the day before yesterday, the same light breeze and golden sun and clear blue sky, the same smell of pine needles, the same cool softness of a mountain summer. But that was a hundred years ago, something crystallized in time, like a fly in amber.*

The Lady in the Lake

High in the mountains, even a world war can seem far away.

Big Bear Dam was built from 1909 to 1925. It drops 125 feet down a narrow canyon and holds back the waters of an eight-by-four-mile lake that serves as the main reservoir for the cities of San Bernardino and Redlands. The road to Big Bear clings precariously to the steep sides of the San Bernardino Mountains. The large numbers of unwary motorists who plunge over the edge every year have earned it the reputation as the most treacherous road in Southern California.

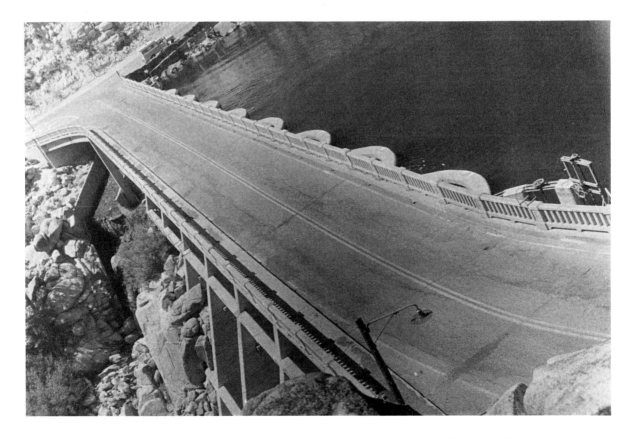

Big Bear Dam and the lake edge.

It was from such cabins like those that Chandler experienced directly the "same smell of pine needles, the same cool softness of a mountain summer." Since Chandler would come up to the mountain resorts for weeks and months at a time, returning almost annually, his mental catalog of the area was built up slowly and with recurring detail.

For more than twenty years, from his marriage to Cissy until they settled in La Jolla just north of San Diego, Chandler had ample opportunity to make similar catalogs at scores of short-term residences around Los Angeles. With a compulsive wanderlust, the Chandlers moved back and forth across Southern California. In between the recurring summers at Big Bear or Lake Arrowhead and winters in La Jolla, they lived (alphabetically) in Arcadia, Bel Air, Cathedral City, Echo Park, Hermosa Beach, Hollywood, Idyllwild, Pacific Palisades, Palm Springs, Redondo Beach, Riverside, San Bernardino, Santa Monica, Silver Lake, Westlake, and the Wilshire district.

The Chandlers' long odyssey through the Southland ended in 1946, when they established a permanent residence in La Jolla, where Chandler remained until Cissy's death in late 1953. After thirty years of marriage, it was to be expected that the loss of Cissy threw Chandler into a prolonged depression, which included a halfhearted suicide attempt just ten weeks after she died. Ultimately Chandler sold his house and lived out his days in rented quarters. He traveled to England, where he spent most of the next two years and went again in 1956 and 1958. Between these trips, Chandler returned to La Jolla. Most of the time, he was in ill health, drinking excessively, frustrated in his relationships with women, and unable to sustain his writing for more than brief periods. He died of pneumonia in La Jolla in March 1959.

59 / CARCASSES

I left Los Angeles and hit the superhighway that now bypassed Oceanside. I had time to think.

From Los Angeles to Oceanside were eighteen miles of divided six-lane superhighway dotted at intervals with the carcasses of wrecked, stripped, and abandoned cars tossed against the high bank to rust until they were hauled away. So I started thinking about why I was going back to Esmeralda. The case was all backwards and it wasn't my case anyway.

Playback

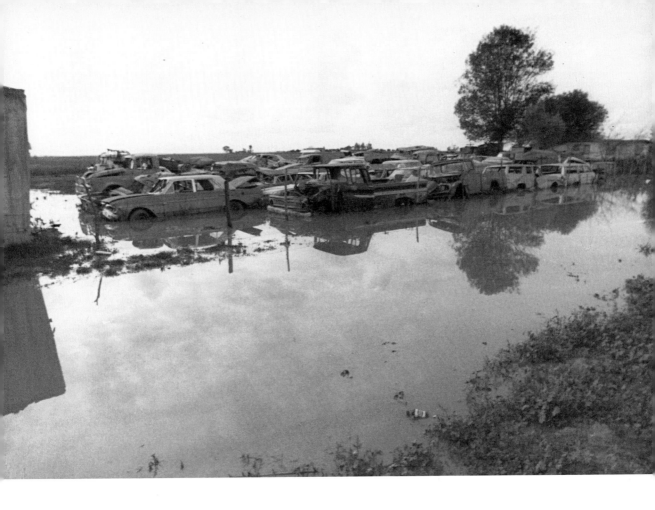

As he grew older, Chandler's metaphors turned to images of death and dying. The dozen years he spent in La Jolla, the real "Esmeralda," were far less productive ones than before. Chandler had succeeded in removing himself from the deadlines and the pecuniary attitude of Hollywood but seemed to lose much of his writer's drive in the process. It was several years after the move south, in 1950, that Chandler had his last and perhaps most frustrating experience as a screenwriter. Partly because he was curious to work with a filmmaker of the stature of Alfred Hitchcock and partly because he admired the novel, Chandler agreed to adapt Patricia Highsmith's *Strangers on a Train*.

Chandler's deal called for him to be paid weekly and to work at home, so Hitchcock had to drive down to La Jolla for story conferences. As with prior collaborations, this one quickly soured; and, of course, there was a deadline because East Coast exteriors had to be shot before the winter weather. In the end, Chandler was taken off salary by Warner Brothers and had to share credit with a second writer brought in by Hitchcock to revise his draft.

Playback, Chandler's last novel, was loosely based on his earlier screenplay for Universal and set in "Esmeralda." It may well be because his creator had taken him south, out of Los Angeles and out of his element, that Marlowe seems so ill at ease. In 1956 Chandler confessed that "I know what is the matter with my writing or not writing. I've lost any affinity for my background. Los Angeles is no longer my city I know damn well I sound like a bitter and disappointed man. I guess I am at that."[18]

House off Palm Canyon Drive, Palm Springs.

Realty office, Palm Springs.

Chandler was staying in Palm Springs when he finished *Playback* in 1957, and he was inspired to start "The Poodle Springs Story." Although only four chapters were ever completed, it is quickly apparent that Marlowe, like Chandler, has lost his affinity for his background. He finds himself living in what his wife describes as "a new section of the Springs, darling. I rented the house for the season. It's a bit on the chi-chi side, but so is Poodle Springs." By the time he visits a realtor, who tells him, "Offices are hard to find, Mr. Marlowe," the detective may be ready to hang it all up.

Marlowe never found an office in Poodle Springs, but he made it back to Los Angeles in Chandler's last story. Published posthumously under four different titles (see Bibliography), the story is most often referred to as "The Pencil." Marlowe is back in Hollywood and unmarried (his marriage in "The Poodle Springs Story" was never consummated through publication, so Chandler simply "annulled" it); but his attitude has changed. Probably as a reflection of Chandler's own disenchantment with Los Angeles, Marlowe is more critic than cynic. There is no reference to Marlowe's age; but he is clearly older. The underlying irony is that, for all the time that has passed, Marlowe himself and his situation are essentially unchanged. In one of his last letters, Chandler summed up his protagonist: "I think he will always have a fairly shabby office, a lonely house, a number of affairs, but no permanent connection I see him always in a lonely street, in lonely rooms, puzzled but never quite defeated."[19]

In 1957, Chandler complained that "Los Angeles . . . was hot and dry when I first went there, with tropical rains in winter and sunshine at least nine-tenths of the years. Now it is humid, hot, sticky, and when the smog comes down into the bowl between the mountains which is Los Angeles, it is damn near intolerable."[20] In *his* final assessment of the city, Marlowe is less bitter but similarly dismayed: "It was a nice fall night—or as nice as they get in Los Angeles' spoiled climate—clearish but not even crisp. I don't know what's happened to the weather in our overcrowded city; but it's not the same weather I knew when I came to it."

60 / VALLEY MOONLIGHT

*T*he wind was quiet out here and the valley moonlight was so sharp that the black shadows looked as if they had been cut with an engraving tool.

Around the curve the whole valley spread out before me. A thousand white houses built up and down the hills, ten thousand lighted windows and the stars hanging down over them politely, not getting too close . . .

The High Window

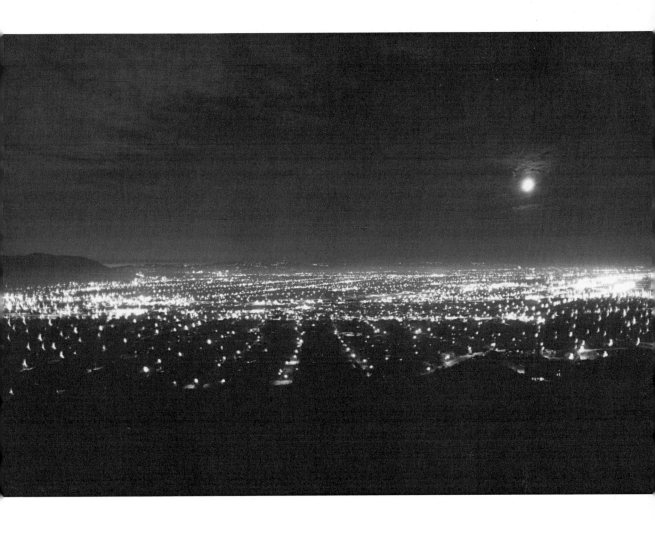

The number of lights in the Valley has increased considerably since Marlowe drove over Sepulveda Boulevard. Now an Interstate cuts through the Santa Monica Mountains, and the glow of high-intensity streetlights is visible even before cresting the ridge.

Under the Spaniards, this wide, flat basin stretching out northwest of Los Angeles proper was known as "Los Encinos," after the groves of wild oaks. The Franciscans built a mission at the northern edge in 1797 for which the Valley is now named, but little in the Valley changed. After the Civil War, two German immigrants, Lankershim and Van Nuys, brought in sheep and wheat, and in 1876 the rail link to San Francisco was completed through the independent town of San Fernando and a seven-thousand-foot tunnel from downtown Los Angeles. Still little was changed until 1913, when the first water coursed 233 miles down Mulholland's aqueduct from the Owens Valley, out through the spillway, and into the Van Norman Reservoir just three miles north of the old mission. The earthenwork dam holding back the water was just a large-scale version of one the missionary friars put up in 1799, which created the earliest recorded dispute with Los Angeles over water rights. This aqueduct water clearly belonged to Los Angeles, which had spent nearly two million dollars bringing it south. Forty thousand people came out to The Cascades to witness the opening and hear Mulholland's brief speech: "There it is. Take it."

In 1915 Los Angeles had begun annexing all of the San Fernando Valley (except for the small portion that was already incorporated). The arrival of the water first transformed the Valley into a vast plain of farms and orchards. As Los Angeles's population grew at the rate of 100,000 a year until World War II and at an even greater clip after that, the Valley was transformed into a vast bedroom community, offering reasonably priced housing to those willing to commute, starting at North Hollywood just over the Cahuenga Pass and moving inexorably westward. Ventura Boulevard, which Marlowe used to cross the Valley in the days before the freeway, (as in the following excerpt) separated the low-cost suburbs from the more expensive enclaves of Woodland Hills, Sherman Oaks, and Encino in the southern foothills.

Encino is where the Lennoxes lived in *The Long Goodbye*, "high on the hill where the big houses were." In *The High Window*, Marlowe describes a drive into an exclusive section of Sherman Oaks: "Escamillo Drive made three jogs in four blocks, for no reason that I could see. It was very narrow, averaged about five homes to a block and was overhung by a section of shaggy brown foothill on which nothing lived at this season except sage and manzanita. In its fifth and last block, Escamillo Drive did a neat little curve to the left, hit the base of the hill hard, and died without a whimper."

61 / YOU'RE NOT HUMAN TONIGHT, MARLOWE

I drove east on Sunset but I didn't go home. At La Brea I turned north and swung over to Highland, out over Cahuenga Pass and down on to Ventura Boulevard, past Studio City and Sherman Oaks and Encino. There was nothing lonely about the trip. There never is on that road. Fast boys in stripped-down Fords shot in and out of the traffic streams, missing fenders by a sixteenth of an inch, but somehow always missing them. Tired men in dusty coupés and sedans winced and tightened their grip on the wheel and ploughed on north and west towards home and dinner, an evening with the sports page, the blatting of the radio, the whining of their spoiled children and the gabble of their silly wives. I drove on past the gaudy neons and the false fronts behind them, the sleazy hamburger joints that look like palaces under the colors, the circular drive-ins as gay as circuses with the chipper hard-eyed car-hops, the brilliant counters, and the sweaty greasy kitchens that would have poisoned a toad. Great double trucks rumbled down over Sepulveda from Wilmington and San Pedro and crossed towards the Ridge Route, starting up in low-low from the traffic lights with a growl of lions in the zoo.

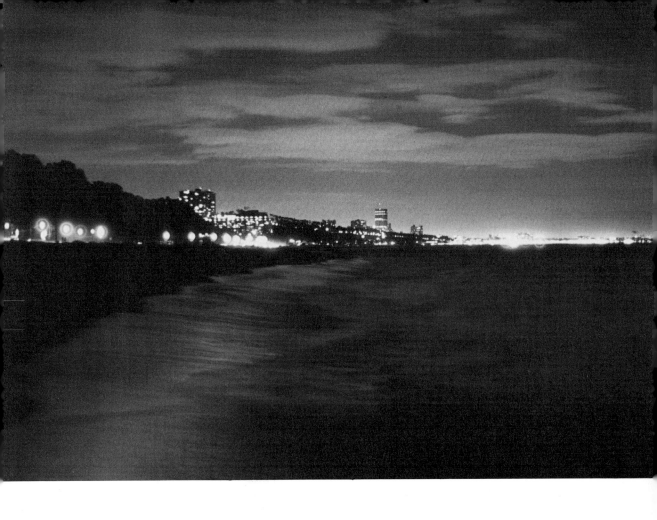

Behind Encino an occasional light winked from the hills through thick trees. The homes of screen stars. Screen stars, phooey. The veterans of a thousand beds. Hold it, Marlowe, you're not human tonight. The air got cooler. The highway narrowed. The cars were so few now that the headlights hurt. The grade rose against chalk walls and at the top a breeze, unbroken from the ocean, danced casually across the night. . . .

I drove on to the Oxnard cut-off and turned back along the ocean. The big eight-wheelers and sixteen-wheelers were streaming north, all hung over with orange lights. On the right the great fat solid Pacific trudging into shore like a scrubwoman going home. No moon, no fuss, hardly a sound of the surf. No smell. None of the harsh wild smell of the sea. A California ocean Here we go again. You're not human tonight, Marlowe. . . .

Malibu. More movie stars. More pink and blue bath-tubs. More tufted beds. More Chanel No. 5. More Lincoln Continentals and Cadillacs. More wind-blown hair and sunglasses and attitudes and pseudo-refined voices and water-front morals. Now, wait a minute. Lots of nice people work in pictures. You've got the wrong attitude, Marlowe. You're not human tonight.

I smelled Los Angeles before I got to it. It smelled stale and old like a living room that had been closed too long. But the colored lights fooled you. The lights were wonderful. There ought to be a monument to the man who invented neon lights. Fifteen stories high, solid marble. There's a boy who really made something out of nothing.

The Little Sister

preceding page:
Looking south along Pacific Coast Highway toward Santa Monica from Will Rogers Beach.

When things get tough, Marlowe likes to go for a drive. The trip in *The Little Sister* is his longest, purely comtemplative excursion. For no reason in particular he heads north out of Hollywood through the San Fernando Valley and into Ventura County before swinging south back to L.A. along the coast, a trip of some seventy-odd miles. The cities, the suburbs, the highways themselves, for Marlowe these are all a sideshow, and his car is a refuge. Down these mean streets we all must go, none of us wanting to believe that we are tarnished or quite yet defeated.

SELECTED BIBLIOGRAPHY

From 1933 to 1959, Raymond Chandler published seven novels and twenty-three short stories. One of his film scripts (*Double Indemnity*) was also published during his lifetime. Published after Chandler's death were the last Marlowe short story (under various titles, see below); another short story ("A Couple of Writers"); an unfinished novel ("The Poodle Springs Story"); a novella (*English Summer*); and two screenplays (*The Blue Dahlia* and *Playback*).

Chandler's work has been widely reprinted, anthologized, and translated. For the sake of simplicity, this bibliography lists Chandler's writing chronologically from its appearance in book form. Twenty of the short stories were collected in two volumes, *The Simple Art of Murder* and *Killer in the Rain*. These stories and all seven novels are still in print in paperback. (The stories from *The Simple Art of Murder* appear in three separate paperbacks: *The Simple Art of Murder*, *Trouble Is My Business*, and *Pick-up on Noon Street*.)

The most extensive collection of Chandler's work, including numerous out-of-print editions and original manuscripts, is housed in the Special Collections Division of the UCLA Research Library. The excerpts used in this book are taken only from the seven novels and the stories collected in the original edition of *The Simple Art of Murder*.

There is also a vast array of material on Los Angeles and its history at the UCLA Research Library, as well as at the Los Angeles Public Library downtown, particularly in the California History Room. For a graphic presentation of Southern California history, Lando Hall at the Los Angeles Natural History Museum has a permanent display of models and relief maps. Numerous organizations sponsor tours and publish pamphlets and periodicals on Los Angeles and Southern California history, in particular the Los Angeles Conservancy and the California Historical Society.

1. NOVELS

The Big Sleep. New York: Alfred A. Knopf, 1939.

Farewell, My Lovely. New York: Alfred A. Knopf, 1940.

The High Window. New York: Alfred A. Knopf, 1942.

The Lady in the Lake. New York: Alfred A. Knopf, 1943.

The Little Sister. Boston: Houghton Mifflin, 1949.

The Long Goodbye. Boston: Houghton Mifflin, 1954.

Playback. Boston: Houghton Mifflin, 1958.

2. SHORT STORIES, PUBLISHED SCRIPTS, AND ANTHOLOGIES

"Blackmailers Don't Shoot" (short story). *Black Mask* (December 1933).

"The Bronze Door" (short story). *Unknown*, No. 11 (November 1939).

Double Indemnity (script), with Billy Wilder. *Best Filmplays of 1945*. Edited by John Gassner and Dudley Nichols. New York: Crown, 1946.

The Simple Art of Murder. (Includes the essay "The Simple Art of Murder," and the short stories: "Finger Man," "Smark Aleck Kill," "Guns at Cyrano's," "Pick-up on Noon St.," "The King in Yellow," "Goldfish," "Pearls Are a Nuisance," "I'll Be Waiting," "Red Wind," "Nevada Gas," "Spanish Blood," and "Trouble Is My Business".) Boston: Houghton Mifflin, 1950.

"Professor Bingo's Snuff" (short story). *Go* (June-July, 1951).

"The Pencil" as *"Wrong Pigeon"* (short story, a.k.a., "Marlowe Takes on the Syndicate," and "Philip Marlowe's Last Case"). *Manhunt*, No. 8 (February 1961).

Raymond Chandler Speaking (Includes the short story, "A Couple of Writers" and the fragment, "The Poodle Springs Story".) Edited by Dorothy Gardiner and Kathrine Sorley Walker. Boston: Houghton Mifflin, 1962.

Killer in the Rain (Includes the short stories: "Killer in the Rain," "The Man Who Liked Dogs," "The Curtain," "Try the·Girl," "Mandarin's Jade," "Bay City Blues," "The Lady in the Lake," and "No Crime in the Mountains".) Boston: Houghton Mifflin, 1964.

Chandler Before Marlowe: Early Prose and Poetry, 1908-1912. Edited by Matthew J. Bruccoli. Columbia: University of South Carolina Press, 1973.

The Notebooks of Raymond Chandler and English Summer: A Gothic Romance. Edited by Frank MacShane. Illustrated by Edward Gorey. New York: Ecco Press, 1976.

The Blue Dahlia (script). Edited by Matthew J. Bruccoli. Carbondale: Southern Illinois University Press, 1976.

Selected Letters of Raymond Chandler. Edited by Frank MacShane. New York: Columbia University Press, 1981.

Raymond Chandler's Unknown Thriller: The Screenplay of Playback. New York: The Mysterious Press, 1985.

3. BOOKS AND ARTICLES ABOUT CHANDLER AND HIS WORK

Brackett, Leigh. ''From 'The Big Sleep' to 'The Long Goodbye' and More or Less How We Got There.'' *Take One*, IV, 1 (September-October, 1972), pp. 26-28.

Durham, Philip. *Down These Mean Streets a Man Must Go*. Chapel Hill: University of North Carolina Press, 1963.

Gross, Miriam, ed. *The World of Raymond Chandler*. New York: A & W Publishers, 1977.

Luhr, William. *Raymond Chandler and Film*. New York: Frederick Ungar, 1982.

MacShane, Frank. *The Life of Raymond Chandler*. New York: Dutton, 1976.

————.''He Was a Dead Shot with a Wisecrack.'' *T.V. Guide* (April 16, 1983), pp. 40-42.

Morgan, Neil. ''The Long Goodbye.'' *California Magazine*, VII, 6 (June 1982), pp. 91, 159-164.

Pendo, Stephen. *Raymond Chandler, His Novels into Film*. Metuchen, New Jersey: Scarecrow Press, 1976.

Thorpe, Edward. *Chandlertown, the Los Angeles of Philip Marlowe*. New York: St. Martin's Press, 1983.

Zolotow, Maurice. ''How Raymond Chandler Screwed Hollywood.'' *California Living* (July 20, 1980), pp. 12-15.

4. BOOKS AND ESSAYS ABOUT LOS ANGELES AND ENVIRONS

Basten, Fred. *Santa Monica Bay: the First Hundred Years*. Los Angeles: Douglas-West, 1974.

———.*Main St. to Malibu*. Santa Monica, California: Graphics Press, 1980.

Bradley, David. "City of The Big Sleep." *Signature* (August 1979), pp. 44-47, 56-57.

Caughey, John, and Caughey, LaRee. *Los Angeles, Biography of a City*. Berkeley: University of California Press, 1977.

Clark, David. *L.A. On Foot*. Los Angeles and San Francisco: Camaro Publishing, 1972.

Clark, David. *Los Angeles, a City Apart*. Woodland Hills, California: Windsor Publications, 1981.

Dash, Norman. *Yesterday's Los Angeles*. Miami, Florida: E. A. Seemann, 1976.

Dietz, Lawrence. "Raymond Chandler's L.A." *West* (December 14, 1969), pp. 22f.

Fontanini, Steve; Wittich, Bill; and Sister Anne Marie. *Chester Place*. Los Angeles: Mount St. Mary's, 1982.

Gebhard, David, and Von Breton, Harriette. *L.A. in the Thirties, 1931-1941*. Salt Lake City: Peregrine Smith Books, 1975.

Gebhard, David, and Winter, Robert. *Architecture in Los Angeles*. Salt Lake City: Peregrine Smith Books, 1985.

Gill, Brendan, and Moore, Derry. *The Dream Come True*. New York: Lippincott & Crowell, 1980.

Heimann, Jim, and Georges, Rip. *California Crazy*. San Francisco: Chronicle Books, 1980.

Heimann, Jim. *Hooray for Hollywood*. San Francisco: Chronicle Books, 1980.

Hermann, Cleve. *At Large in L.A.* Los Angeles: May Publishing, 1979.

Hill, Lawrence. *La Reina: Los Angeles in Three Centuries*. Los Angeles: Security Trust, 1929.

Hunt, John. *Los Angeles Official Handbook*. Los Angeles: Board of Public Works, 1969.

Keyes, John D., supervising ed. *Los Angeles*. New York: Hastings House, 1941.

Kuehn, Gernot. *View of Los Angeles*. Los Angeles: Portriga Publications, 1978.

Lamparski, Richard. *Lamparski's Hidden Hollywood*. New York: Simon & Schuster, 1981.

Landau, Robert, and Pashdag, John. *Outrageous L.A.*. San Francisco: Chronicle Books, 1984.

Levenstein, Bruce. *Landmarks*. Los Angeles: Made in L.A., 1978.

McWilliams, Carey. *Southern California: An Island on the Land*. Salt Lake City: Peregrine Smith, 1973.

Marinacci, Barbara, and Marinacci, Rudy. *Take Sunset Blvd: The Fabulous New Way to See L.A.* Novato, California: Presidio Press, 1981.

Marcus, Greil and Goodwin, Michael. "The Law is Where You Buy It." *City*, VIII, 64 (April 30-May 13, 1975), pp. 23-25.

Miller, Wendy; Abbott, Helen; Hathaway, Bo; and Ackland, Don. *The Best of Los Angeles*. Los Angeles: Rosebud Books, 1980.

Moore, Charles; Becker, Peter; and Campbell, Regula. *The City Observed: Los Angeles*. New York: Random House, 1984.

"On the Trail of Philip Marlowe, Hollywood to Santa Monica." *Sunset* (July 1977), pp. 54, 57.

Pierson, Robert John. *The Beach Towns*. San Francisco: Chronicle Books, 1985.

Prelutsky, Burt. *How to Survive in the City*. Los Angeles: Lakeworld, 1971.

Reck, Tom S. "Raymond Chandler's Los Angeles." *The Nation* (December 20, 1975), pp. 661-662.

Rolfe, Lionel. *Literary L.A.* San Francisco: Chronicle Books, 1981.

Schessler, Kenneth. *This Is Hollywood*. Los Angeles: Southern California Books, 1980.

Seidenbaum, Art, and Malmin, John. *Los Angeles 200*. New York: Abrams, 1980.

Shippey, Lee. *It's an Old California Custom*, New York: Vanguard, 1948.

Shippey, Lee, and Yavno, Max. *The Los Angeles Book*. Boston: Houghton Mifflin, 1950.

Smith, Jack. *L.A.*. New York: Pinnacle Books, 1981.

Thomas Bros. Maps. *Los Angeles and Orange Counties Street Atlas*. Los Angeles: Thomas Bros., 1983, 1984, 1985.

Tucker, Terry. *Greetings from Los Angeles*. Cambridge, Massachusetts: Steam Press, 1982.

Weaks, Dan. "Private Eyes." *California Magazine*, VII, 6 (June 1982), pp. 84-90.

Weinstock, Matt. *My L.A.*. New York: Wyn, 1947.

William, Sweet. *Venice of America*. Los Angeles: Constitutional Capers, 1976.

Wurman, Richard Saul. *LA/ACCESS*. Los Angeles: Access, 1980.

FILMOGRAPHY

Motion-picture versions have been made of all of Chandler's novels except *Playback*. There have been three adaptations of *Farewell, My Lovely*, two of *The Big Sleep*, and two of *The High Window*. Chandler worked on the script of one adaptation, that of *The Lady in the Lake*, for which he was uncredited (see Notes to Excerpt 25).

Chandler did not write any of the radio or television versions of his fiction. In 1947 NBC produced a summer replacement radio show with Van Heflin as Marlowe. The following year, CBS began production of a regular radio series that ran through 1951; Gerald Mohr was Marlowe in the original scripts. CBS made a pilot for a television series in 1949 but did not go on to a series. That same year, a teleplay of *The Little Sister* was produced. In 1954, an hour-long version of *The Long Goodbye* starring Dick Powell was televised as part of the "Climax" series. Neither Chandler nor any of his agents succeeded in arranging for a Marlowe television series until 1959. It starred Philip Carey as Marlowe and aired for one season after Chandler's death. Most recently Thames Television of London produced a limited television series starring Powers Boothe, based on the Marlowe stories and entitled, "Marlowe, Private Eye." In the United States, the series has been shown by HBO.

Chandler's unproduced film writing, in addition to *Playback*, includes the screenplay *The Innocent Mrs. Duff*, based on the novel by Elisabeth Sanxay Holding, and the short treatment *Backfire*.

Cary Grant was Chandler's own "ideal" choice for Marlowe, but of the actors who actually played the role while Chandler was still living, he preferred Humphrey Bogart: "Bogart, of course, is so much better than any tough-guy actor that he makes bums of the Ladds and the Powells. As we say here, Bogart can be tough without a gun. Also he has a sense of humor that contains the grating undertone of contempt Bogart is the genuine article."[21]

1. MOTION PICTURES BASED ON WORK BY CHANDLER

The Falcon Takes Over. (RKO, 1942). Produced by Howard Benedict. Directed by Irving Reis. Script by Lynn Root and Frank Fenton. Based on a character created by Michael Arlen. Adapted from the novel *Farewell, My Lovely*. Starring George Sanders (the Falcon), Lynn Bari (Ann), James Gleason (O'Hara). 63 minutes.

Time to Kill. (Twentieth Century-Fox, 1942). Produced by Sol M. Wurtzel. Directed by Herbert Leeds. Script by Clarence Upson Young. Based on a character by Brett Halliday and the novel

The High Window. Starring Lloyd Nolan (Mike Shayne), Heather Angel (Merle), Doris Merrick (Linda), Richard Lane (Breeze). 61 minutes.

Murder, My Sweet. (RKO, 1944). Produced by Adrian Scott. Directed by Edward Dmytryk. Script by John Paxton, based on the novel *Farewell, My Lovely*. Starring Dick Powell (Philip Marlowe), Claire Trevor (Velma), Anne Shirley (Anne), Otto Kruger (Amthor), Mike Mazurki (Moose), Don Douglas (Randall). 95 minutes.

The Big Sleep. (Warner Bros., 1946). Produced (uncredited) and directed by Howard Hawks. Script by William Faulkner, Leigh Brackett, and Jules Furthman, based on the novel *The Big Sleep*. Starring Humphrey Bogart (Philip Marlowe), Lauren Bacall (Vivian), John Ridgely (Eddie Mars), Martha Vickers (Carmen), Regis Toomey (Bernie Ohls). 118 minutes.

The Lady in the Lake. (MGM, 1947). Produced by George Haight. Directed by Robert Montgomery. Script by Steve Fisher, based on the novel *The Lady in the Lake*. Starring Robert Montgomery (Philip Marlowe), Lloyd Nolan (Degarmo), Audrey Totter (Adrienne), Leon Ames (Derace), Tom Tully (Kane), Jayne Meadows (Mildred). 105 minutes.

The Brasher Doubloon. (Twentieth Century-Fox, 1947). Produced by Robert Bassler. Directed by John Brahm. Script by Dorothy Hannah, adapted by Dorothy Bennett and Leonard Praskins from the novel *The High Window*. Starring George Montgomery (Philip Marlowe), Nancy Guild (Merle), Conrad Janis (Murdock), Roy Roberts (Breeze), Marvin Miller (Blair). 72 minutes.

Marlowe. (MGM, 1969). Produced by Gabriel Katzka and Sidney Beckerman. Directed by Paul Bogart. Script by Stirling Silliphant, based on the novel *The Little Sister*. Starring James Garner (Philip Marlowe), Gayle Hunnicutt (Mavis), Carroll O'Connor (French), Rita Moreno (Dolores), Sharon Farrell (Orfamay), William Daniels (Crowell). 95 minutes.

The Long Goodbye. (United Artists, 1973). Produced by Elliott Kastner and Jerry Bick. Directed by Robert Altman. Script by Leigh Brackett, based on the novel *The Long Goodbye*. Starring Elliott Gould (Philip Marlowe), Nina Van Pallandt (Eileen), Sterling Hayden (Roger), Mark Rydell (Marty), Henry Gibson (Verringer). 112 minutes.

Farewell, My Lovely. (Avco Embassy, 1975). Produced by George Pappas and Jerry Bruckheimer. Directed by Dick Richards. Script by David Zelag Goodman, based on the novel *Farewell, My Lovely*. Starring Robert Mitchum (Philip Marlowe), Charlotte Rampling (Velma), John Ireland (Nulty), Sylvia Miles (Jesse), Anthony Zerbe (Brunette), Jack O'Halloran (Moose). 97 minutes.

The Big Sleep. (United Artists, 1978). Produced by Elliott Kastner and Michael Winner. Direction and script by Michael Winner, based on the novel *The Big Sleep*. Starring Robert Mitchum (Philip Marlowe), Sarah Miles (Charlotte), Oliver Reed (Eddie Mars), Richard Boone (Canino), Candy Clark (Camilla), Joan Collins (Agnes), James Stewart (Sternwood). 100 minutes.

2. SCREENPLAYS BY CHANDLER

Double Indemnity. (Paramount, 1944). Produced by Joseph Sistrom (uncredited). Directed by Billy Wilder. Script by Raymond Chandler and Billy Wilder, based on the novella *Double Indemnity* by James M. Cain. Starring Fred MacMurray (Neff), Barbara Stanwyck (Phyllis), Edward G. Robinson (Keyes). 106 minutes.

And Now Tomorrow. (Paramount, 1944). Produced by Fred Kohlmar. Directed by Irving Pichel. Script by Frank Partos and Raymond Chandler, based on the novel *And Now Tomorrow* by Rachel Field. Starring Alan Ladd (Vance), Loretta Young (Emily), Susan Hayward (Janice), Barry Sullivan (Stoddard). 85 minutes.

The Unseen. (Paramount, 1945). Produced by John Houseman. Directed by Lewis Allen. Script by Hagar Wilde and Raymond Chandler, adapted by Wilde and Ken Englund from the novel *Her Heart in Her Throat* by Ethel Lina White. Starring Joel McCrea (Fleming), Gail Russell (Elizabeth), Herbert Marshall (Evans), Richard Lyon (Fielding). 81 minutes.

The Blue Dahlia. (Paramount, 1946). Produced by John Houseman. Directed by George Marshall. Script by Raymond Chandler. Starring Alan Ladd (Morrison), Veronica Lake (Joyce), William Bendix (Buzz), Howard DaSilva (Harwood), Hugh Beaumont (George). 98 minutes.

Strangers on a Train. (Warner Bros., 1951). Produced and directed by Alfred Hitchcock. Script by Raymond Chandler and Czenzi Ormonde, adapted by Whitfield Cook from the novel *Strangers on a Train* by Patricia Highsmith. Starring Farley Granger (Guy), Robert Walker (Bruno), Ruth Roman (Anne), Leo G. Carroll (Morton). 101 minutes.

NOTES

1. Frank MacShane, *The Life of Raymond Chandler*, p. 15.

2. Letter to Hamish Hamilton, November 10, 1950 in Frank MacShane, *Selected Letters of Raymond Chandler*, p. 236; and Dorothy Gardner and Kathrine Sorley Walker, eds., *Raymond Chandler Speaking*, p. 25.

3. MacShane, *Life*, p. 29.

4. Letter to Hamish Hamilton, November 10, 1950 in *Letters*, p. 236 and *Speaking*, p. 26.

5. Letter to D. J. Ibberson, April 19, 1951 in *Letters*, pp. 270-274 and *Speaking*, pp. 227-231.

6. Ibid.

7. Ibid.

8. Ibid.

9. Ibid.

10. Letter to Edgar Carter, June 3, 1957, in *Letters*, p. 452.

11. Letter to D.J. Ibberson in *Letters*, p. 271 and *Speaking*, p. 229.

12. Letter to Hamish Hamilton, June 10, 1952 in *Speaking*, p. 234.

13. Letter to Roger Manchel, February 7, 1955, in *Letters*, p. 383.

14. Letter to Maurice Guinness, February 10, 1958, in *Letters*, p. 473 and *Speaking*, p. 248.

15. Letter to Edgar Carter, June 3, 1957, in *Letters*, p. 452.

16. Raymond Chandler, "Writers in Hollywood," *Atlantic Monthly* (November 1945) reprinted in *Speaking*, p. 116.

17. Ibid., p. 121.

18. Letter to Jessica Tyndale, July 12, 1956 in *Letters*, p. 405.

19. Letter to Maurice Guinness, February 21, 1959 in *Letters*, p. 483 and *Speaking*, p. 249.

20. MacShane, *Life*, pp. 252-253.

21. Letter to Hamish Hamilton, May 30, 1946 in *Letters*, p. 75 and *Speaking*, pp. 216-217.

REGARDING THE PHOTOGRAPHS

All of the photographs were taken by the authors beginning in 1979, using two 35mm Olympus cameras (an OM 1 and an OM 10) with Zuiko 21mm, 28mm, and 50mm (high-speed) primes and a Tokina 5:1 zoom lens (50mm to 250mm). Most of the photographs were taken with Ilford FP4 black-and-white film, although some of the earliest were taken with Kodak Plus-X or Panatomic-X. The negatives were processed either at the Los Angeles Art Photographers Association (LAPA), Santa Monica, California, or by the authors. All the original prints were made by the authors at LAPA on Ilford multigrade papers.

ACKNOWLEDGEMENTS

Thanks are due first of all to Peter Mayer and Mark Gompertz of Overlook for their ideas and their unflagging patience. For their moral and sometimes physical support (camera equipment can get heavy), we are indebted to Roberta Ward, Christiane Silver, Rebecca Parr, Adrian Turner, Nancy Blair, Marci Carlin, Richard Prince, Jim Paris, John Welch, Jeffery Ward, David Bradley, Patrick Regan, and Harriette Ames-Regan. We also received valuable comments and suggestions from Bruce Kimmel, Dennis White, Anne Schlosser, Howard Prouty, Kathleen Ellsworth, Robert Schoenman, Carol Sheef, Mary Ann Bonino, and Rochelle Reed. We got assistance with some of the high angles from John Hunt, Dolores Copeland, and Mike Schenk. For getting her feet wet, we thank Terry Bergen-Flom.

Many negatives were processed by Jean Pritchard at LAPA. Darkroom work at the LAPA rental darkroom was assisted by Scott Sing and Craig Kovacs. We are grateful to them, as well as to Ben and Ronna Mendelson, the owners of the LAPA gallery, for all their friendly support.